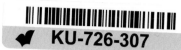
BOBBY BAKER: THE REBEL AT THE HEART OF THE JOKER

Marina Warner

'There are three things that are real: God, human folly and laughter. Since the first two pass our comprehension, we must do what we can with the third.' Valmiki, quoted in the Ramayana

'Whatever you do, laugh and laugh and that'll stop him.' Ingrid Bergman to Ann Todd about Hitchcock's dirty jokes

Take a Peek!, Bobby Baker's new performance piece, began with a sequence of coloured pencil drawings, self-portraits showing the artist in the form of one of those stiff Neolithic fertility figurines, arms by her sides, legs close together. But in her case her body was opening up, showing its bounty – and its poisons. In one drawing, her figure is divided into internal compartments, like a chemist's wall cabinet, and from under the flaps come unpredictable fluxes and oozings ('bodily emissions'). In another, the effigy has become a doll's house, with storeys of furniture and books which the artist has annotated: 'The desire for order – body and household possessions – neat and tidy – PROPERLY LOOKED AFTER'. Other drawings show her head exploding with a burst of silver lucky charms, a breast fountaining with blood, and her body segmented into flower beds, 'growing useful herbs'. This woman is seeking to be of service: in one image she looks like one of those Egyptian corn effigies, which were planted with seed and placed in the grave to sprout. These private sketches strip away the comic play-acting which Bobby Baker uses to present herself in performance, and they reveal the work's roots in profound and painful self-exposure.

In *How to Shop* (1993), her previous piece, Bobby Baker combined the idea of a management training lecture with a housewife's weekly supermarket experience; in *Take a Peek!* she has taken up the question of women's bodies more directly than ever before, and spliced a woman's unexplained ordeals in hospital and clinic with the shows and shies of a traditional fairground. The public are hustled and bustled through in a series of nine moving tableaux and invited at each stage to participate in some way. The sequence is highly structured, very clearly thought through, as Bobby Baker's work always is. *Take a Peek!*, commissioned by the South Bank Centre and part of the 1994 LIFT (London International Festival of Theatre), is the artist's third piece in a projected series of five, and her most ambitious performance to date. Co-directed by Bobby Baker's longtime collaborator Polonca Baloh Brown, it involves two other actors performing and dancing with her, Tamzin Griffin and Sian Stevenson, and is being staged first on a terrace at the Royal

Festival Hall, and then on tour in a series of purpose-built spaces and booths designed by the architects Fraser, Brown, McKenna.

In the first booth, Bobby Baker is displayed, bundled up in nine of the stiff cotton overalls that have become her trademark costume (as Pierrot has his pyjamas and Harlequin his motley): she's The Fat Lady, a freak in a booth; this corresponds to the Waiting Room stage in the hospital narrative that pulses disturbingly under the whole piece. Explosions of entertainment and acrobatics interrupt the exploration of the nameless female complaint, as the spectators, taking a peek, follow the artist through the Nut Shy, during which she's pelted with hazelnuts, then on through to the Show Girls where she performs an acrobatic dance with the others to a hurdy-gurdy. She is making a spectacle of herself, as Charcot's patients were made to do during his lectures on hysteria in the Salpêtrière hospital in Paris in the 1880s. (Freud owned a lithograph of one of these sessions, showing a young woman displayed in a contorted trance, and it is still hanging, above the famous couch, in the Freud Museum.) When Bobby Baker saw the images of herself grimacing, taken by Andrew Whittuck (her husband), she realised they caught the feeling of the photographs that Charcot had taken of his patients, most of whom were women, to illustrate the passions that surfaced in the hysterical condition.[1]

Each phase of her journey through *Take a Peek!* is marked by a fresh, enigmatic, painfully absurd and peculiar sign of the body, as consuming and consumed: oversize melons in a string bag; kumquats swimming in a plastic bag, looking like fairground goldfish; bubble-pack ice cubes filled with Guinness; grass and dirt in a round jug. Each of these signs are again reproduced in photographs Andrew Whittuck has made to accompany the piece, which approach their odd subjects with the cold formal precision of the most highly skilled commercial food photography. The audience of *How to Shop* also came away with ironically glossy souvenirs: handsome postcards of items in that show's series of ordeals, like a bowl of croutons, labelled 'LOVE'.

When Bobby Baker was a student at St Martin's, the contemporary artists she most liked were Claes Oldenburg and Roy Lichtenstein, and her interest in objects and food was partly shaped by Pop Art's approach. Her time at St Martin's was also the period when Gilbert and George were first appearing as Living Sculptures and beginning to send round their mail art pieces – traces of their breakfast that day, clippings from their hair. While they have turned to two dimensional imagery for the wall, however, Bobby Baker is continuing to use herself as

subject and object at once, and to explore pathos and the absurd in daily life.

In 1972, when she first baked a cake – in the shape of a baseball boot – and carved it and iced it, Bobby Baker recalls:

I looked at this object, and when I thought of carrying it into the college, as a *sculpture*, sitting on my grandmother's cake plate, it was as if the heavens opened and light fell on it – it was *so* funny and rebellious.

Later, Bobby Baker performed a tea party, offering cakes and meringues to invited friends, and there came a second vision, more painful, and more crucial to the subsequent course of her work:

I made fun of myself, as I had often done in the past, and everyone laughed immoderately. I was utterly distraught. But then everything began to fit. It was quite the most extraordinary sensation. I had been turning myself inside out yearning to be other than myself, but I realised then in one instant that I had to go back into myself, use that and work with that and put it into my art – and that I could do that anywhere.

In that discomfort, when she was laughed at, in that clash between the audience's response and the earnest effusions of the caring tea party giver, Bobby Baker's performance art is rooted. Through it she provides for others, both in reality and in mimicry in such performance pieces as *Drawing on a Mother's Experience* (1988) and *Kitchen Show* (1991). She could be called a hunger artist, working with her own cravings and the common needs of people for sustenance, for comfort, for nourishment, of which food is the chief sign and the chief embodiment in the real world.

The hungers Bobby Baker represents build on her own self-portrait, and the revelations she makes are so open they provoke embarrassment. Embarrassment, that emotion that is close to the intimacies of shame, also depends on arbitrary social codes: it's not one of the grand passions, the cardinal virtues or the seven deadly sins, but that doesn't make it less important, less acutely felt. Her use of embarrassment corresponds to her interest in working with the most mundane and overlooked daily tasks (cooking, shopping) and using everyday materials (packaging) and trinkets (a gold ankle chain). The theatre of embarrassment in her hands turns out the lining of all these ordinary processes and stuffs and makes them raw and deep; she works with what is concealed in the domestic, the homely and the banal and exposes its complexity, with humour, imagination and remarkable sensitivity to its submerged reefs of pain.

In *Take a Peek!* Bobby Baker wants to avoid lulling the audience into a false sense of security through her comic self-parody; this performance is planned to be raw, unsettling, even violent in its relations between subject and audience. She has defined the really effective works of art as those which:

. . . appear like the structure of a cell rushing through the air, so that you can still grasp it intuitively though all you can see are its blurred edges. This reflects the reality of experience,

in which one can't really grasp what is going on.

Attending *Take a Peek!* as part of the audience should communicate this same feeling of rush and bewilderment, as the audience too are bundled about and asked to do this, to do that, without explanation.

Although the illness or the disorder in *Take a Peek!* is never defined – or never found – the piece communicates the female patient's predicament, as she is passed on from one investigation or examination to another, each stage appallingly transmogrified into fairground entertainments. Each time she is handed on, she sheds one more overall, as if approaching the anatomy theatre for the final operation. However, by a blissful reprieve, in the climax of the piece, she's undressed to take a blessed, easeful bath instead, in chocolate custard. She emerges from this smeared and speckled all over with hundreds and thousands, those tiny coloured grains of sugar for cake decoration.

So *Take a Peek!* ends in celebration: in the spirit of 'Look we have come through'. The catharsis of its ending corresponds to the bittersweet triumphs which have brought other Bobby Baker performances to reverberating conclusion: in *How to Shop*, for instance, she ascended into heaven on a hoist, a virtuous housewife who has done her job more than properly; in *Kitchen Show*, she tucked J-cloths into her shoes to give herself wings to fly, and then perched herself on a revolving cake stand, with the J-cloths still standing out stiffly from her heels, and memorably began to turn, like a clumsy, poignant, female Eros of sink, stove and cooking spoon.

These narratives of feeding and being fed, however, are highly ambiguous in their picture of home victories. For her first major piece, performed in 1976, *An Edible Family in a Mobile Home*, Bobby Baker made life-size figures out of cake dough worked on to chicken wire, as if the dough were papier mâché, and set them out like figures in a doll's house, in rooms lined with newspapers and magazines: beauty pin-ups in the girl's bedroom where she was lying on the bed, reading; and comics in the boy's room. The Mother had a teapot for her head, which Bobby Baker used to pour a cup for her visitors, as she invited them in to eat the family.

At the end of the installation of *An Edible Family*, when all that was left of the figures was a stain on the floor and a mass of twisted chicken wire, Bobby Baker realised, as she had not done before, how fundamentally transgressive she had been, how she had in effect made a model of her own brother and sister, mother and father, and herself. The revelation was distressing, but the work crystallised her approach: in the most normal scenes of everyday life, she would find disturbance. The game of 'Let's pretend' in her art reveals how much is truly pretence.

An Edible Family in a Mobile Home defined a very powerful and recurrent theme in Bobby Baker's original art of performance: the piece was a profane communion, a family tea party in which the family was eaten, so that the most polite, indeed genteel national ritual of friendship became an ogre's banquet. The artist who nearly 20 years ago made effigies of her own

family out of cake can now present herself, at the close of *Take a Peek!*, emerging out of confusion and physical suffering into the blissful state of gratification, a childhood fantasy of pleasure and sweetness, fit for licking all over, good enough to eat.

This kind of an ending is again intertwined with the theme of communion in her work: it reflects the structure of a ritual like the Mass, which in its Protestant form does end with the ceremony of the Eucharist, which represents the eating of the body and blood of Christ by the congregation. The Mass mirrors his passion, death and resurrection, in a ritual pattern which demands that sacrifice take place before rebirth and renewal can happen.

Bobby Baker's father was a Methodist, and she went to a Methodist school; her grandfather was so strict that when she made an aeroplane out of putty on a Sunday, and gave it to him, he pulped it with a scowl. On her mother's side, there are 'strings of vicars'. She is still a Christian, and owns up to it; an unusual act in itself for a contemporary artist, but the principles and discipline of the religion are intrinsic to her pieces. The abjection she records is bound up with the idea of suffering and humiliation as a resource; she inflicts mortifications on her own body, as in the horrific moment in *How to Shop* when she put a tin of anchovies in her mouth, under her cheeks, stretching her face from ear to ear in a ghastly mockery of a virtuous smile as in Reformation images of the perfect, silent housewife. She has said that she 'wants to share feelings of no worth, of being humiliated', and does not feel that by enacting them, she compounds them, but rather regains her own power in the act of wilful imitation.

Cannibalism fascinated the Surrealists, as part of the outrageous transgressiveness they cultivated, and Bobby Baker's work also connects with the movement's aesthetics, in her attention to quotidian details, to discovering in everything and anything the quality of the marvellous – what André Breton called *le merveilleux banal*. The macabre feel of *An Edible Family*, and its burlesquing of gentility, is close, too, to Surrealist staging of street scenes and enigmatic incidents, using dummies in combination with fabricated objects in order to mount a political attack against the hypocrisy of the guardians of culture and morality then in power. The word 'banal', with its etymological connection to the Greek word for 'work' and its 16th-century meaning of 'common' or 'communal', has been degraded to mean 'trite' or 'trivial', just as the ordinary work everyone must do has also fallen into disregard, if not contempt. This is especially marked recently with respect to the domestic routines of women and the daily business of mothering – the very territory Bobby Baker makes her own as an arena of art.

Another Surrealist artist, Meret Oppenheim, in several mordantly ironical made objects, likewise explored the connections of the female body and food, of love and nourishment: for example, the pair of bridal shoes trussed and upturned on a dish, with butcher's frills around the heels (*Ma Gouvernante – My Nurse – Mein Kindermädchen*, 1936), and the bread roll in the

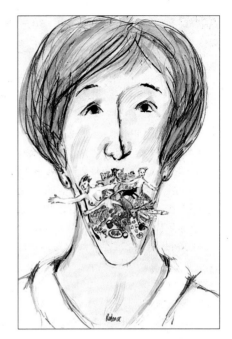

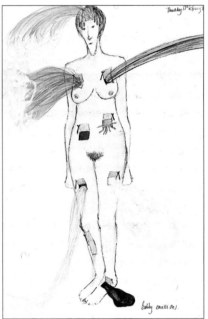

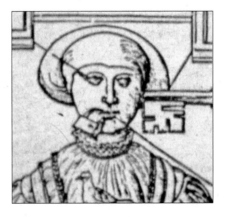

PAGE 2: Take A Peek!, 1995; ABOVE AND CENTRE: Drawings for Take A Peek!, 1994; BELOW: Detail from The Wise Woman by Anton Woensam, c1525. The padlock to her mouth signifies her obedience and discretion
All photographs Andrew Whittuck

shape of a woman showing her vulva, laid on a chess board as place mat, with knife and fork alongside ('Bon Appétit, Marcel!' 1966). Bobby Baker did not merely invite eating in an eternal moment of suspended time; the family was eaten by her guests. This was uncanny, and very comic, too, and it brilliantly realised theories of family conflict and the place of food, as simultaneously the symbol of care and love and the instrument of control and authority: 'I'll be Mother' means taking charge of the teapot.

Similarly, in one of the powerfully bizarre episodes of *How to Shop*, she made a baby out of shaving foam – in an appeal for male help and protection – and then destroyed it. The clash within the very core of the maternal role returned vividly in Bobby Baker's later performance piece, *Drawing on a Mother's Experience* (1988), where she is no longer the daughter but the mother, and is herself feeding and being consumed, physically and mentally. It's a most upsetting piece to watch, and a powerful one; it begins with Bobby Baker, bright and cheery, giving a pretty straight account of the birth of her two children and the first eight years of her life as a mother: there's nothing very dramatic recounted, except for the sudden successful delivery of her son, on the floor, at home, 'on the only rug I hadn't washed'. At each stage in the story, Bobby Baker remembers some item of food – the Guinness she drank to build up her strength, the fish pie her mother brought her; and produces them on stage from a shopping bag, and then uses them to draw (as the *double entendre* of the title promises) on a sheet she has spread on the floor. The result is a kind of mock Jackson Pollock, an action painting made of beer, blackberries and splattered fish pie. Then, at the very end, she rolls herself into the sticky, wet, dribbling mess and stands up and hops, stiffly, in a kind of celebration dance, that she has survived.

On the night I saw it, *Drawing on a Mother's Experience* was performed in a church in Bobby Baker's part of North London. From preference, she would always perform in public spaces in ordinary daily use, like schools, churches and halls (she initially wanted *How to Shop* to take place in a supermarket), and says that her ideal would be to 'take a stool out into the street and stand up on it and do it'; rather in the manner of a lay preacher. She finds her material to hand, never in specialist shops or fancy brand name boutiques; she is developing a vernacular at all levels – dramatic, visual, topographical – and it's intentionally not hip like street jargon, nor nostalgic like dirty realist drama dialect, but the particular urban language of the informal unofficial networks, of the usually disregarded working local community. *Kitchen Show* was patterned on a coffee morning among neighbours; she deliberately broke down the distinction between strangers in the street and family in the house, and it was shocking, in a pleasurable way, to be invited into Bobby Baker's own private kitchen to see her perform.

The audience in the church for *Drawing on a Mother's Experience* responded vividly, with cries and sighs, hoots and giggles, but as Bobby Baker worked towards the end, there was

a hush and tears. The tragicomic atmosphere was under her complete command: she assumes a tone of stoical jollity in the way she tells her story, while her characteristic physical bashfulness adds to the excruciating vulnerability she communicates. We learn of what that body has been through, and though her body is on show in some way on the stage, it remains hidden at the same time, under her recurring uniform, the anonymous starched white overall, through the conventional gestures she adopts. She says, 'In any place I wear an overall I become faceless and voiceless and I find the possibilities of that really interesting.' The laughter she causes isn't mirth; it's sadder, and deeper. It expresses recognition, in both her male and female spectators, of the ordinary human mysteries of life and survival and all the accompanying difficulties that she represents; but it is very far from the kind of collusive laughter that protests provoke. Bobby Baker doesn't come on as a victim, asking for solidarity in her sufferings. Her re-enactment of her experience as a mother is matter-of-fact – no grievances are being aired, no self-pity. But she draws us into her anger at helplessness, and at the corresponding terrors of inadequacy, into understanding her confusion at all the demands and the tasks, and the incommunicability of trying to sustain life.

The Surrealist writer and artist Leonora Carrington said in an interview that for her painting was 'like making strawberry jam, really carefully, really well'; she cultivates 'dailyness' and its pleasures. Similarly, the undercurrent of unease in Bobby Baker's pieces rises up to a surface that must be rich in sensuous delights for her. Recalling *An Edible Family*, she talks of its perfect prettiness at first, before it began to rot and to disintegrate (and be eaten); she remembers 'the irresistible sparkle of the sugar against the newsprint'. Her work is consistently concerned with pleasure, with the lively, connected responses of palate and eye, and inspires her to introduce sensuous surprises in every piece, which are frequently funny because they displace sexual engulfment and bliss. Even in the very midst of recording the humiliations of the body, she will take a pause to admire the dazzling purple of plums, the peachiness of some pale pink stuff. I was reminded of something the writer Colm Tóibín has written about Egon Schiele, another self-portraitist with a taste for performance:

Schiele was so brave in the way he let colour decorate his painting, in the way he would allow pure moments of delight to happen, revelling in the richness of the materials at his disposal so that his sense of mingled disgust and desire at the nature of the body is always mysterious and oddly comic.[2]

Partly, Bobby Baker 'guys' herself as a woman, with all the paradoxes that entails. When she was little, she wanted to be a boy, like so many girls brought up in the 50s with the tomboys Jo in *Little Women* and George in the 'Famous Five' as role models. Her name was Lindsey (itself ambidextrous), but she chose Bobby, and stayed with it. Names are obviously important: in the

game of Happy Families, there was Miss Bun, the baker's daughter, and Bobby hated her for having such red, round cheeks, such 'a diminished creature'. While taking up baking with a vengeance, Bobby Baker was turning on that fat and happy alter ego who was so supine in her lot.

The figures of women in her work often seem to belong in a game too, the game of 'Let's pretend' that she is playing. She conveys the strangeness of all the duties women are expected to fulfil, and her own ambiguous relationship to shopping, cooking and mothering and so forth put in question the naturalness of such activities for women at all. She pinpoints the springs of feelings of worth, and destabilises them, as when, in *How to Shop*, she comments on how accomplished she feels when her trolley is filled with more bargains and healthier items than the next person in the queue. The uniform helps here too, as if she needs the costume to perform correctly in the task of 'being-a-wife-and-mother', but its anonymity and its ungainliness only bring out the imprisonment of gender expectations more vividly. She also seems to affect feminine mannerisms, she has a penchant for baby-pink slippers, slingbacks; even the overalls were to be pale, pale pink. She gives quick nervous little giggles after a phrase in order not to seem too assertive, and to cover up, without really succeeding, feelings of panic and tension. She purposefully adds flurry and fluster in her eagerness to communicate, she dips and nods in a pantomime of social expectations from carers, mothers, homemakers. This, too, is often excruciatingly funny.

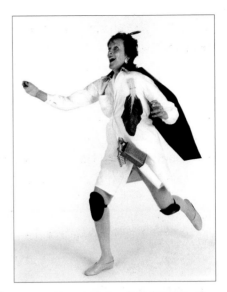

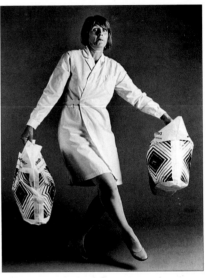

Rituals, sacred and domestic, are sometimes structured to include humour; the festivals of Greece and Rome accorded a hugely important role to comedy, in the raucous satyr plays, for example, which concluded the performance of tragedies, and in the Saturnalia, which survive in some form in carnival topsy-turvy. The Christian liturgy used to include the *risus paschalis*, or Easter laughter, which greeted the resurrection of Christ. Anthropologists have shown the link between the way rituals define identity and belonging, and the way jokes, for example, set borders between Us and Them, or challenge adversity with laughter and confirm a sense of social solidarity. The court jester was allowed, in the guise of jokes, to tell the truth, as the Fool does in *King Lear*. Mary Douglas points out, 'The joke works only when it mirrors social forms; it exists by virtue of its congruence with the social structure.'[3] She goes on to discuss the joker as a ritual purifier among the Kaguru, the Gogo, the Dogon and other African tribes, where a joker enjoys privileges of open speech others are forbidden, and can therefore cleanse the community; his *modus operandi* is different from the straightforward flouting of taboos, however:

> [The joker] has a firm hold on his own position in the structure and the disruptive comments he makes upon it are in a sense the comments of the social group upon itself . . . he lightens for everyone the oppressiveness of social reality, demonstrates its arbitrariness by making light of formality in generality, and expresses the creative possibili-

FROM ABOVE: Kitchen Show – Action No. 12, *1991;* Drawing on a Mother's Experience, *1988*

ties of the situation . . . his jokes expose the inadequacy of realist structurings of experience and so release the pent-up power of the imagination.[4]

Douglas could have been writing about Bobby Baker; her use of the comic mode is interestingly related, given her taste for ritual structures. The women in her childhood – her grandmother and her mother – were given to laughing:

> . . . they laughed at everything and anything which made me angry – great hysterical shrieks and hoots. My grandmother was a very, very frustrated woman – she used to throw things about, and cook very badly and say things, like 'Have a bun', and then throw it at you. But this wicked sense of humour was very, very liberating.

Derision was these older women's way of tackling the world. Freud wrote, in a short essay on 'Humour', that laughing was a powerful means of self-assertion:

> The ego refuses to be distressed by the provocations of reality, to let itself be compelled to suffer. It insists that it cannot be affected by the traumas of the external world; it shows, in fact, that such traumas are no more than occasions for it to gain pleasure . . . Humour is not resigned; it is rebellious. It signifies not only the triumph of the ego but also of the pleasure principle, which is able here to assert itself against the unkindness of the real circumstances.[5]

The various comic modes on which Bobby Baker draws – stand-up patter, self-mockery and burlesque, clowning and pantomime – consist of different ways of acknowledging the state of abjection and making a virtue of it, which is a form of refusal, but not complete denial. Her crucial change is that her humour doesn't taunt or jeer at others, or like a comic, make the audience laugh at others' distress (the banana skin principle). She is the target of the laughter she provokes, but remains in control, however weak and vulnerable she presents herself to be. She said once that going into a local church gave her 'a terrible desire to fall about laughing, or stand up high and just shriek with laughter, because I find it so bizarre – and I have the same reaction in supermarkets. That is really one of the starting points of my work, that irreverence and rebellion and freedom.' Bobby Baker has turned her perception of her own vulnerabilities and folly both as herself and as a woman into a brave show, a new way of fooling: like the jester, she tells the truth but seems to be making mockery while she does it, so that we can bear what she makes us see.

Marina Warner is the author of From the Beast to the Blonde: On Fairy Tales and Their Tellers *and this essay was specially commissioned by the Arts Council Of England.*

Take A Peek! *will be touring later this year and in 1996, to cities in the UK, including Bristol, Coventry and Glasgow. For further details please telephone Artsadmin on 0171 247 5102.*

Notes

1 See Elaine Showalter, *The Female Malady: Women, Madness and English Culture, 1830-1980* (London) 1987, pp147-150.

2 Colm Toíbín, *The Sign of the Cross, Travels in Catholic Europe,* (London) 1994, p121.

3 Mary Douglas, 'Jokes', in *Implicit Meanings: Essays in Anthropology,* (London) 1975, p106.

4 Ibid p107.

5 S Freud, 'Humour', *1928* in *Complete Works, Vol XXI (1927-31)* (London) 1953, pp162-3.

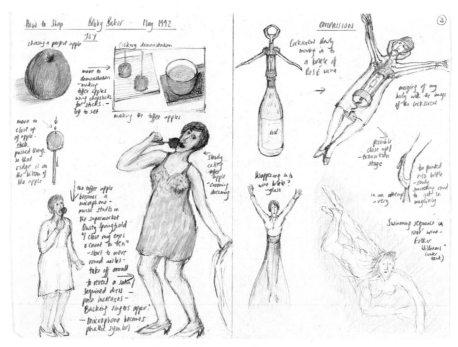

Drawings for How to Shop, *1993*

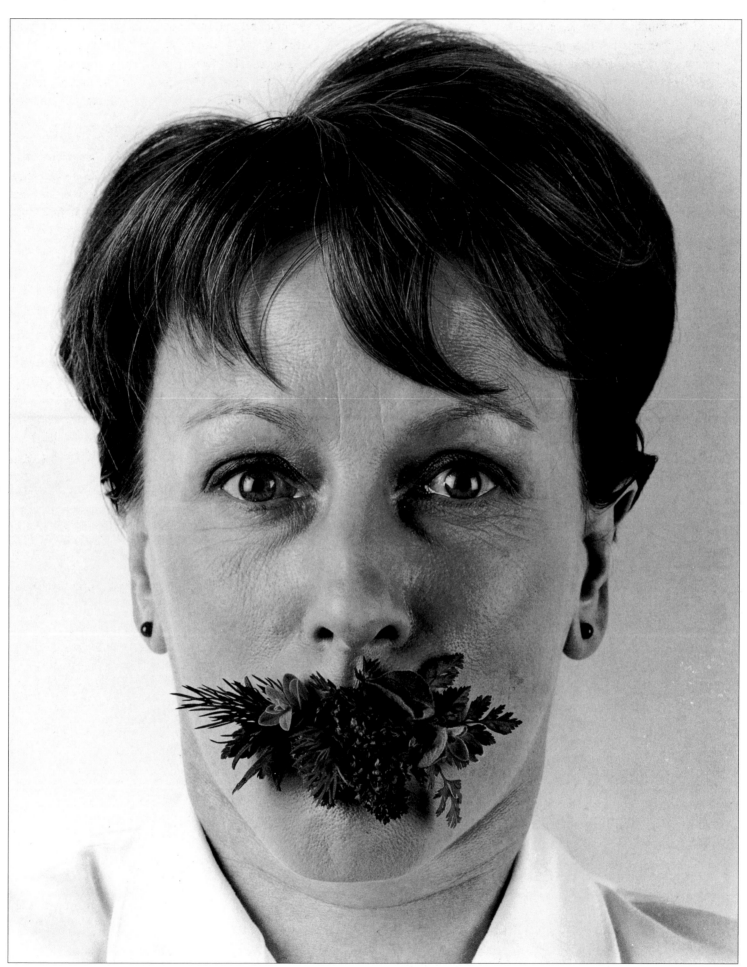

A Useful Body of Herbs – Herb Face, *1994*

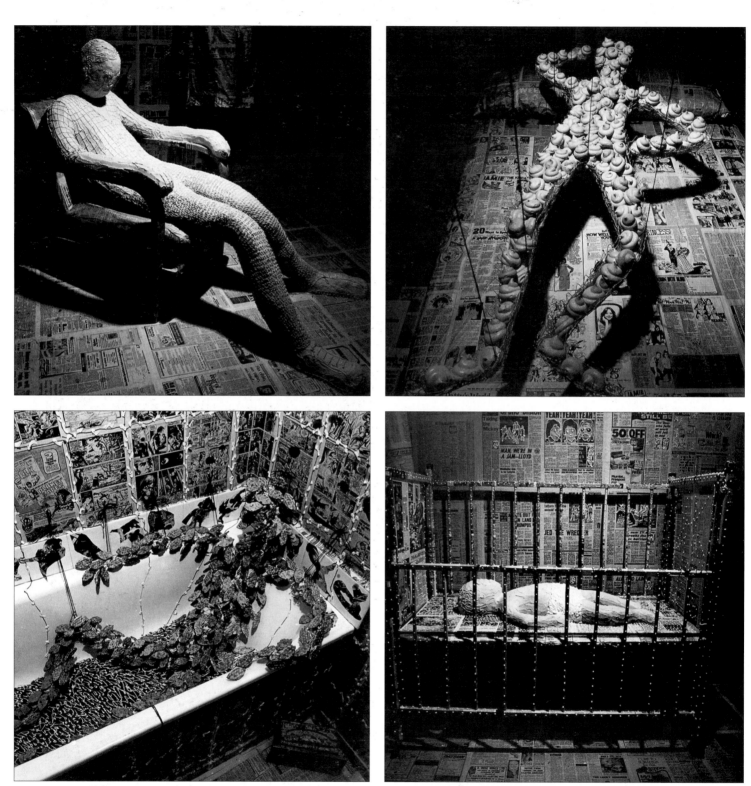

FROM ABOVE, L TO R: Details from An Edible Family in a Mobile Home, *1976.* Father; Teenage Daughter; Son; Baby

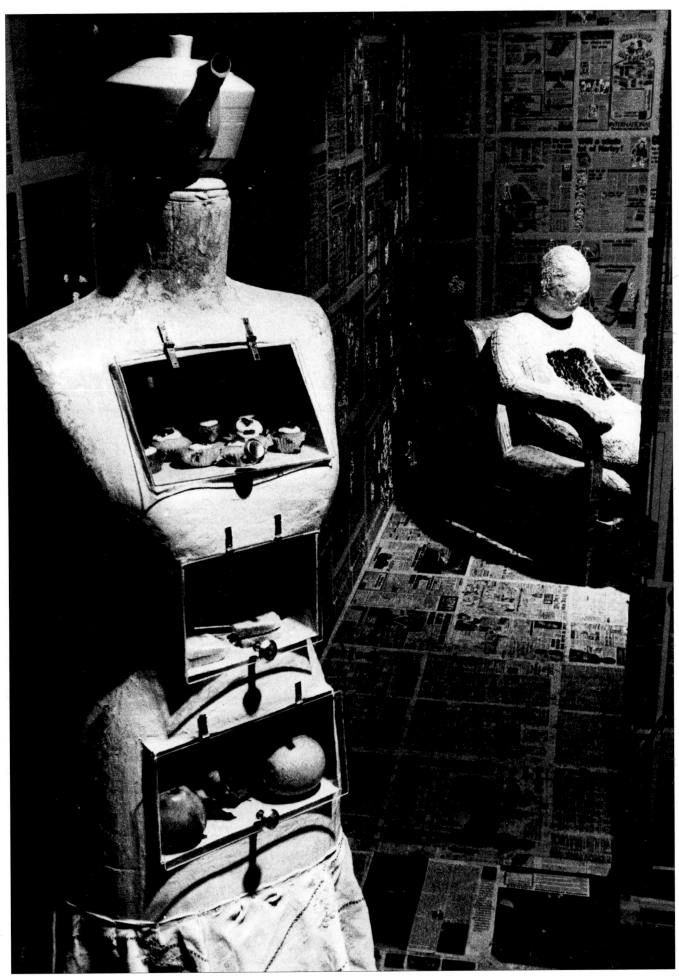

An Edible Family in a Mobile Home – Mother & Father, *1976*

Introduction

Bobby Baker's **HOW TO SHOP** is a complete guide to the art of successful shopping and will be a boon to amateur shoppers everywhere. Packed with handy hints and tips, **HOW TO SHOP** prepares us for the ultimate shopping experience - shopping for life. Bobby draws on her own, extensive shopping expertise to offer advice on all the skills required for success, from acquiring the necessary virtues to time-saving trolley manoeuvres.

HOW TO SHOP is presented in seven easy-to-follow stages, each giving step by step guidance on shopping for the well-nourished spirit. Renowned for her fool-proof approach to the supermarket dash, Bobby Baker will inspire new confidence in even the most tentative shopper. Living proof that shopping can be fun despite the stresses and strains of the supermarket, Bobby's advice is a must for all those intent on improving their progress to the final check out.

This is the first of a set of eight cards being produced in coniunction with **HOW TO SHOP**. Each of the virtues you purchase comes accompanied by a card packed with interesting suggestions and useful information. Collect the set and build your own essential shopping list. Transform your life the Baker way!

Bobby Baker

Bobby Baker, *Expert Shopper*

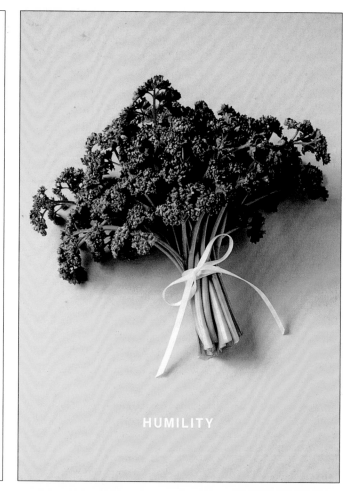

HUMILITY

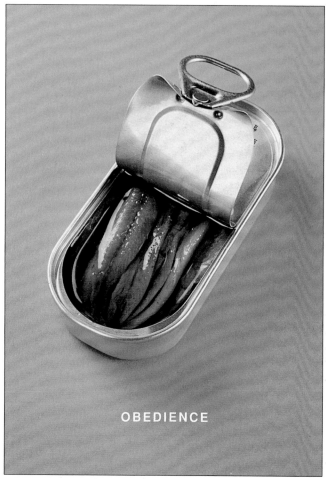

OBEDIENCE

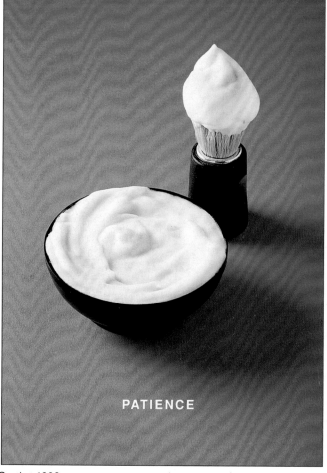

PATIENCE

How To Shop Cards, *1993*

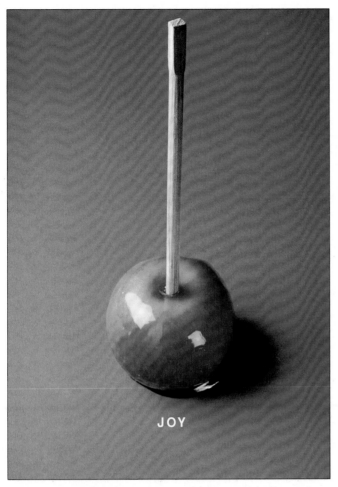

JOY

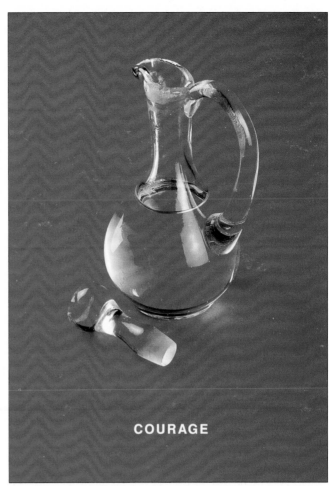

COURAGE

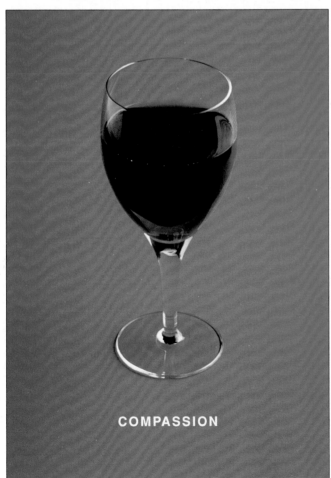

COMPASSION

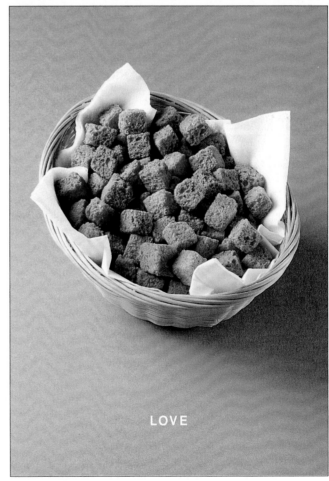

LOVE

How To Shop Cards, *1993*

JPVA
Journal of Philosophy and the Visual Arts

Edited by Andrew Benjamin

The *Journal of Philosophy and the Visual Arts* has set new standards in its exploration of themes central to philosophy's relation to the visual arts, illuminating areas of art criticism, architecture, feminism as well as philosophy itself. Rather than simply reflecting current trends it provides a forum in which the real developments in the analysis of the visual arts and its larger cultural and political context can be presented. Articles by well known philosophers and theorists, as well as some lesser known, together with writings by artists and architects allow a strong interdisciplinary approach reflecting the Journal's roots in post-structural theory.

Other titles in the series include: *Architecture, Space, Painting* JPVA 3; *Philosophy & Architecture* JPVA 2; and *Philosophy in the Visual Arts* JPVA 1.

For further information please contact Academy Group Ltd, 42 Leinster Gardens, London W2 3AN Tel: (0171) 402 2141 Fax: (0171) 723 9540 VCH, 8 Wellington Court, Wellington Street, Cambridge CB1 1HZ, United Kingdom. Tel: (01223) 321111 Fax: (01223) 313321
USA and Canada: VCH Publishers Inc, 303 NW 12th Avenue, Deerfield Beach, FL 33442-1788, USA. Tel: (305) 428 5566/(800) 367 8249 Fax: (305) 428 8201/(800)367 8247
All other countries: VCH, PO Box 10 11 61, 69451 Weinheim, Federal Republic of Germany. Tel: (06201) 606 446/447 Fax: (06201) 606 184.

The Body
JPVA 4

This issue covers in detail the question of art and the human body. Whether there is a sense of being trapped in a body, or of viewing it from the outside, these emotions are frequently externalised in creativity. In a section representing contemporary artists, we encounter Helen Chadwick's androgynously playful creations; Kiki Smith's flayed frames; Matthew Barney's violently erotic images; Bacon's use of 'violence of sensations'; the effect of Thomas Eakin's male nudes on late 19th-century American society. These artists are all profoundly affected by the body and by man's means of reconciling himself with art and the world today – by the sexual, the biological and the physical.

Paperback 1 85490 212 1
278 x 222 mm, 96 pages
Illustrated throughout
1993

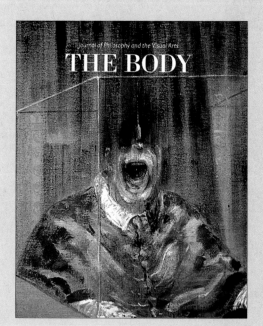

Abstraction
JPVA 5

Abstraction has not only been an important 20th-century art form but has also given rise to one of the most significant and influential schools of criticism. It has almost become inseparable from its critical reception. Rather than accepting this as given, and thus as inevitable, this issue of the *Journal of Philosophy and the Visual Arts* will seek to offer different interpretations of abstraction. Texts by some of the leading philosophers and critics writing today, including Jean-Francois Lyotard, John Rajchman, John Lechte, Nick Millett, Stan Allen, Andrew Benjamin, David Moos and Maia Damianovic, accompany features on work by some of the leading artists working currently in the field of abstraction, such as Albert Ayme, Lydia Dona, David Reed, Jessica Stockholder, Fabian Marcaccio and Thérèse Oulton.

Paperback 1 85490 402 7
278 x 222 mm, 96 pages
Extensively illustrated throughout
April 1995

Complexity
Architecture/Art/Philosophy

JPVA 5

'Beginning with complexity will involve working with the recognition that there has always been more than one. Here however this insistent "more than one" will be positioned beyond the scope of semantics; rather than complexity occurring within the range of meaning and taking the form of a generalised polysemy, it will be linked to the nature of the object and to its production. Complexity, therefore, will be inextricably connected to the ontology of the object. What this means is that complexity, in resisting the hold of a semantic idealism on the one hand, and the attempt to give to it the position of being the basis of a new foundationalism on the other, becomes a way of thinking both the presence and the production of objects.' Andrew Benjamin

Complexity is the original presence of plurality and has been one of the most productive ideas within the visual arts, philosophy and architecture over the last few years. Rather than seeing complexity as providing a new foundation either for the sciences or the arts, complexity in this issue will be linked to the affirmation of heterogeneity and thus to the possibility of complex beginnings. It features the work of many philosophers, theorists, artists and architects including Felix Guattari, Bernard Cache, Greg Lynn, Jean Jacque Lecercle, Arakawa and Madeline Gins, Bernard Tschumi, Bracha Lichtenberg Ettinger and Christine Buci-Glucksman.

Paperback 1 85490 417 5
278 x 222 mm, 96 pages
Over 30 illustrations, mostly in colour
October 1995

JPVA
JOURNAL OF PHILOSOPHY AND THE VISUAL ARTS NO 6

COMPLEXITY
ARCHITECTURE / ART / PHILOSOPHY

FÉLIX GUATTARI · BRACHA LICHTENBERG ETTINGER · BERNARD TSCHUMI
JEAN-JACQUES LECERCLE · CHRISTINE BUCI-GLUCKSMANN · BERNARD CACHE
ARAKAWA / GINS · GREG LYNN · FABIAN MARCACCIO · KATH RENARK JONES

SUBSCRIPTIONS

| UK: | £10/4 issues |
| Europe: | £12/4 issues |

29 Poets Road
London N5 2SL

UNTITLED

A quarterly review of contemporary art

PHOTOGRAPHY
IN THE VISUAL ARTS

Graham Budgett, Diomira, *from* Visible Cities, *1992, toned silver print,*
152.4 x 101.6cm (see pp70-73)

Art & Design

PHOTOGRAPHY
IN THE VISUAL ARTS

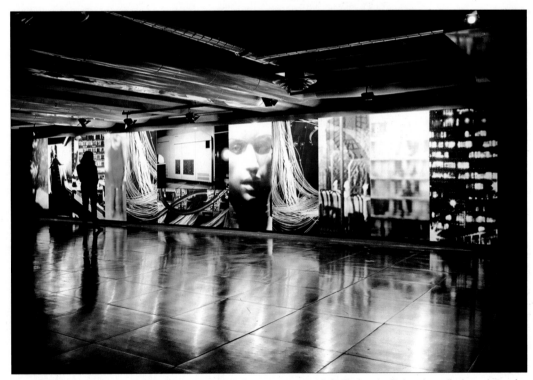

OPPOSITE: Peeter Linnap, Summer 1955 (see pp54-9); ABOVE: Lewis Baltz, Installation view of Ronde de Nuit in the Centre George Pompidou, Paris, 1992, a series of 12 cibachrome works each 200 x 100cm

ACADEMY EDITIONS • LONDON

Acknowledgements

All photographic material is copyright and provided courtesy of the artist. We would like to express our gratitude to the following individuals and galleries for their help and assistance in obtaining the illustrative materials used in this issue: **The Mirror of the World** *pp6-10* p6 Stephane Couturier, courtesy Polaris, Paris; p9 Yves Lomax; p10 (below) Mari Mahr; p8 Helen Sear; p10 (above) Hiroshi Sugimoto, courtesy Jay Jopling, London; **The Image of the World Subverted** *p11* Stephane Couturier, courtesy Polaris, Paris; **Pictures From the Street** *pp12-15* Essay by John S Weber reproduced by permission *Edition Fricke & Schmid* (Berlin); images courtesy Joachim Schmid; **The Mise-en-Scène of the Everyday** *pp16-23* p16 Lynne Cohen, courtesy PPOW Gallery, New York; pp18, 19 (above) Andreas Gursky, courtesy Monika Sprüth Galerie, Cologne; pp19 (below), 20 Candida Höfer; p22 Thomas Struth; **Springfield Hospital Corridors** *pp24-27* courtesy Public Art Development Trust; **Documentary Fictions** *pp28-36* p34 (above) Julian Germain; p35 John Kippin; p32 Karen Knorr; p30 Gilles Peress, courtesy *Contrejour* (Paris); p28 Paul Reas; p36 Paul Seawright; p34 Larry Sultan; **The Persistence of Memory** *p37* Mari Mahr; **Susan Trangmar** *pp38-45* all images courtesy the artist; **The Sense of Time Passing in Photography** *pp46-53* p46 (above) Ania Bien; p52 Sarandos Diakopoulos, courtesy John Stathatos; p48 Nikos Panayotopolous; p50 John Stathatos; p46 (below) Elizabeth Williams; **Summer 1955** *pp54-59* all images courtesy Peeter Linnap; **The (Mis)adventures of Photographic Memory** *pp60-68* p60 Dominique Auerbacher, courtesy Centre Regional de la Photographie; p64 Lewis Baltz, courtesy Galerie Michèle Chomette, Paris; p68 (above left) Pascal Kern, courtesy Gallerie Zabriskie, Paris; p68 (below) Corinne Mercadier, courtesy Galerie Isabelle Bongard, Paris; p62 Denis Roche, reproduced by permission Maeght Editions, Paris; p68 (above right) Seton Smith; p62 Holger Trulszch; **The Constructed Image** *p69* Calum Colvin; **Visible Cities** *pp70-3* images courtesy Graham Budgett; **An Art of Consciousness** *pp74-77* p74 (above) Graham Budgett; p74 (below) Calum Colvin; p75 Olivier Richon; **Jeff Wall** *pp78-86* pp78, 80/81, 82 courtesy Marion Goodman Gallery, New York; p83 courtesy Galerie Johnen & Schottle, Cologne; p84 courtesy the artist; p85 courtesy Patrick Painter Editions; p86 courtesy Vancouver Art Gallery, Vancouver; **The Frustrations of Transgression** *p87* Andres Serrano, courtesy Paula Cooper Gallery, New York; **From the Carnal to the Virtual Body** *pp88-96* p90 Zarina Bhimji, courtesy Public Art Development Trust; p93 Damien Hirst, courtesy Jay Jopling, London; p94 Inez van Lamsweerde, courtesy TORCH Gallery, Amsterdam, p96 Inez van Lamsweerde, courtesy Theatregroep Mug met de Gouden Tand; p88 Andres Serrano, courtesy Paula Cooper Gallery, New York; p93 Oliviero Toscani, Creative Director, United Colors of Benetton.

FRONT COVER: Catherine Yass, Springfield Hospital Corridors, *1994, courtesy Public Art Development Trust*
INSIDE COVERS: Susan Trangmar, detail from Amidst II, *1994, reproduced in full on pp40-41, courtesy the artist*

EDITOR: Nicola Kearton SUB-EDITOR: Iona Baird
ART EDITOR: Andrea Bettella CHIEF DESIGNER: Mario Bettella DESIGNER: Toby Norman

First published in Great Britain in 1995 by *Art & Design* an imprint of
ACADEMY GROUP LTD, 42 LEINSTER GARDENS, LONDON W2 3AN
Member of the VCH Publishing Group
ISBN: 1 85490 224 5 (UK)

Art & Design Profile 44 is published as part of *Art & Design* Vol 10 9/10 1995
Art & Design Magazine is published six times a year and is available by subscription

Distributed to the trade in the United States of America by
NATIONAL BOOK NETWORK, INC, 4720 BOSTON WAY, LANHAM, MARYLAND 20706

Printed and bound in Italy

Contents

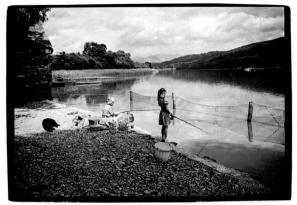

John Kippin, Surveillance Fishing, *Lake District, 1992,*
126.4 x 97.8cm

ART & DESIGN PROFILE No 44
PHOTOGRAPHY IN THE VISUAL ARTS
Guest-edited by John Stathatos

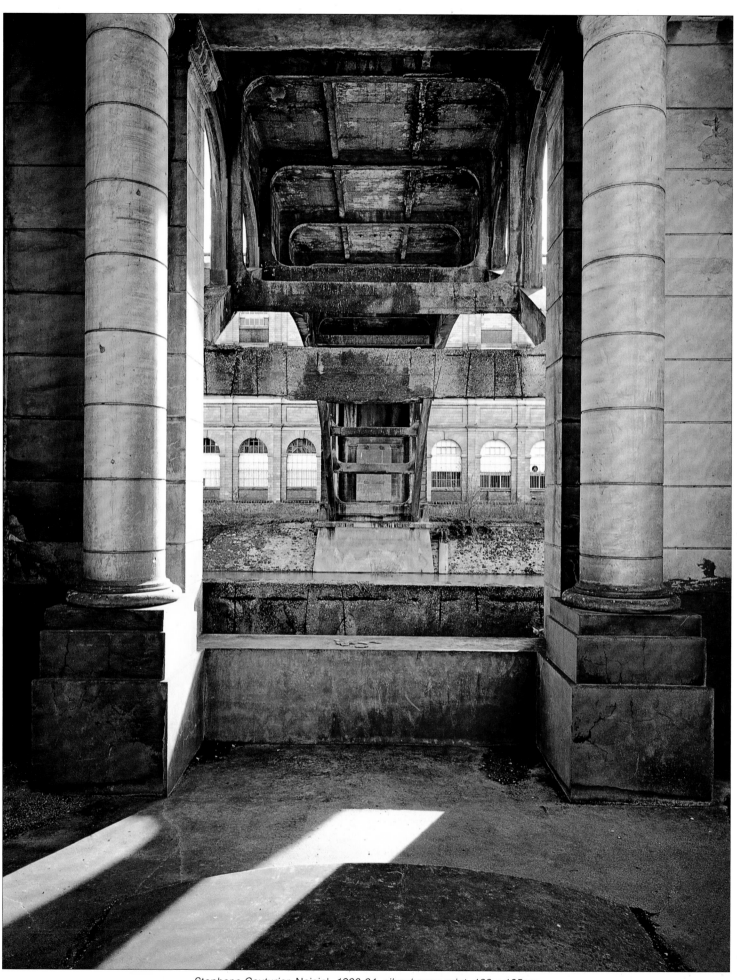

Stephane Couturier, Noisiel, 1993-94, cibachrome print, 130 x 105cm

THE MIRROR OF THE WORLD
JOHN STATHATOS

Before the invention of photography, a reflection was the closest it was possible to get to an exact facsimile of the world. Other than in mirrors of glass or polished metal, or in sheets of still water, the capturing of a reflection remained an unattainable ideal. That this was an ideal is beyond dispute, since the purpose of the visual arts was for many centuries the achieving of the greatest possible exactitude in the imitation of nature. In Pliny's famous anecdote of the painting competition between Zeuxis and Parrhasios, victory hinged on the fact that while Zeuxis' painted grapes fooled the birds which flew down to feed on them, Parrhasios' painted curtain fooled even his rival. For Pliny, and presumably his readers, the successful imitation of life appears to have been the sole measure of success; certainly no mention is made in the *Natural History* of any other desirable qualities.

Socially speaking, pre-photographic representation was a privilege of the rich and powerful, but it was also an activity hedged about with reservations and taboos. To depict the world is in some way to define and control it; more obviously and immediately, depiction privileges certain facets of the world while relegating others. Family photograph albums are a good example of this principle, summing up private histories in terms of highly codified representational conventions in which what is not shown is as important as what is.

The interesting thing about the Zeuxis anecdote is the value it places on trickery. It is well known that mirrors are tricky and unreliable, that reflections are treacherous. With time, we have come to realise that photography too is a treacherous and unreliable mirror, never more so than when it pretends to innocence. Precisely because of this feigned innocence, the photographic image was at first only grudgingly allowed into the pantheon of the visual arts; the mirror, seemingly capable of nothing more than passive reflection, could lay no claim to inspiration. This exclusion was further reinforced by photography's inherently polymorphous nature, a factor which allowed individual images to shift disconcertingly from the 'functional' to the 'artistic' and back again.

Nowadays, photography is almost omnipresent within the visual arts. The essays and portfolios which follow examine a few of the ways in which the photographic image is currently being used by artists. The four areas of discourse proposed as a framework do not of course tell the whole story, nor are they even mutually exclusive; they do however reflect certain wider categories by which a substantial proportion of contemporary photo-based work can be defined. The process whereby a particular artist might be placed in one category rather than another is largely arbitrary; by prioritising production methods rather than intention, for example, Catherine Yass' images could have been included in the third as convincingly as in the first.

In at least three of the four categories, photography is valued for its ability to mirror the world, however unreliably. Of all the methods of representation, only photography can claim this unique relationship with reality: that which has been photographed once existed, however briefly, in the real world. To be reflected in the mirror, a thing or person must first have been.

The first category derives from photography's now discredited claim of impartial testimony. It includes images which, while they may seem to do nothing more than illustrate their subjects, are in fact subversive of the very notion of innocence or neutrality; they are, in other words, considerably more than the sum of information ostensibly contained within them. The mirror, in the case of these photographs, is a convex one, gathering light and information from beyond its apparent boundaries.

The second category, whose emphasis is on the functioning of memory, considers the way in which straightforward photographic images are used by artists for their metaphorical content and power of resonance. Crucial to this reading of photographs is the process by which they change with time; it is well known that the patina of nostalgia is an accretion which can give even the most undistinguished of documentary photographs an emotional charge. Whether the image is new or recent, it is this link with the physical world which is important here.

The vast category of manufactured or constructed images, including staged photography, in-camera manipulation, post-production intervention and, most recently, digital manipulation of all kinds, cannot depend on this implicit emotional appeal. As Ian Jeffrey writes in his illuminating essay, 'Any real photograph makes demands, quite apart from the claims of authorship, because it is rich in traces of the premeditated. Constructors dispense with such givens.' As a result, constructed photography is usually more likely to aim at an intellectual rather than an emotional impact.

The final area of photographic discourse to be addressed is that of transgression. Transgression covers, as it were, a multitude of sins. Sexual behaviour remains the most popular subject, needing little encouragement from the somatic obsessions of the last decade; closely related subjects include mutilation, sado-

ABOVE: Helen Sear, The Surface Beneath, *1990, silver and cibachrome prints with light grid, 335.3 x 91.4cm; BELOW, L TO R:*

Hiroshi Sugimoto, Ordovician Period, *1992, silver print, 50.8 x 61cm; Mari Mahr, from* A Few Days in Geneva, *silver print, 61 x 91.4cm*

masochism and necrophilia. Another kind of taboo which has come under increasing assault is that of privacy, whether of the artist or the subject; to reveal all has become as much an obsession in artistic as in journalistic circles. In some cases, of course, it is possible to combine the two major modes by chronicling one's own sexual behaviour and/or that of one's friends and neighbours. Curiously enough, while interest in transgressive art is probably universal, certain national cultures seem to specialise in it. For whatever one might make of it, a large proportion of sexually explicit work originates in the United States, while, rather more unexpectedly, a number of French artists appear obsessed with beating down the boundaries of privacy.

It is not surprising that the transgressive impulse should have come to rest in photography and video. Transgressive art must by definition aim at a maximum of representational authenticity, but painting or sculpture, no matter how realistic, cannot properly fulfil this brief; only the viewer's knowledge that what is represented actually took place offers full, if short-term, satisfaction. It becomes more than ever important for work of this kind to mirror some reality, however murky and claustrophobic that reality may be. Indeed, given the Western world's accelerating millenarian hysteria, it might be that transgressive art offers, however grotesquely, a distorted but not entirely fictional image of the world. At the end of the first Christian millennium, sadomasochistic impulse was discharged through religious hysteria and displaced onto monastic flagellants; today, the elevation of art into a form of religious impulse offers us on the one hand the perverse narcissism of a self-mutilating Orlan, and on the other the sombre iconic sermons of Andres Serrano.

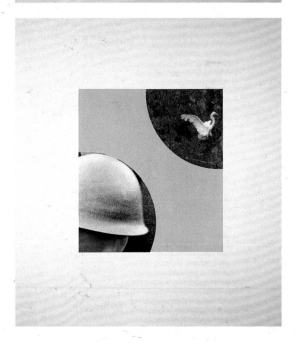

Yves Lomax, from Sometime(s), *1994, cibachrome prints, all approx 89 x 89cm*

Stéphane Couturier, Renault, *1993-94, cibachrome print, 105 x 130cm*

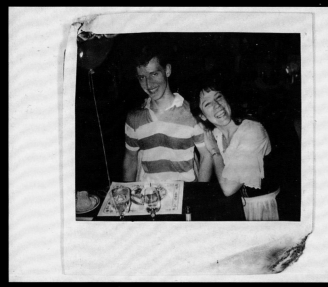

ABOVE, L TO R: No.75, Berlin, May 1990; No. 246, Paris, October 1994; No. 44, Los Angeles, July 1988; No.54, Cairo, February 1989;
photographic media

PICTURES FROM THE STREET

JOACHIM SCHMID

JOHN S WEBER

The first thing likely to strike you about Joachim Schmid's *Pictures from the Street* is that the photographs themselves are utterly and unexpectedly fascinating, both as visual artefacts and human documents. The second is that these snapshots, ID photos and photobooth discards aren't really art at all and were never intended by their makers to be published or exhibited. But since 1982, Schmid has found and collected nearly 300 photographs that were formerly lost, thrown away, driven over, torn up, walked on, soaked by the rain and faded by the sun. Today they form an expanding conceptual art work which ironically redefines the accepted genre of fine-print 'street photography' and stakes a claim as far as possible from nearly everything photographic that has yet made it into a museum or onto an art gallery wall.

At the heart of Schmid's work lies a radical rejection of art photography as generally practised by fine art photographers from the 19th century to the present. Like nearly all of his projects, *Pictures from the Street* relies exclusively on found photographs derived from non-art contexts – in this case photographs lost, abandoned and often deliberately destroyed by their owners, then appropriated by Schmid as bedraggled photographic 'readymades'. Together, they energetically refute the idea that artistic ambition or intention count for much of anything in determining a photograph's potential 'art value' or visual interest. Dismissing the art photographer's attempt to manipulate the medium to his or her own ends, Schmid concentrates on the meta-voice of photography as a whole. Among other things, his work can be read as an extended proposition that 'non-art' photographs are likely to be more compelling than the self-consciously composed efforts of aspiring gallery stars.

Specific images in *Pictures from the Street* suggest particular stories, but none of them can be read with any certainty. A strangely-coloured portrait from Hamburg (*No.1*) and a magnificently eroded black and white photo from Berlin (*No.111*) suggest ID cards or passports and evoke rites of passage such as school, or the administrative presence of state and employer in the life of the individual. One unusual image, *No.82, Berlin, July 1990*, is apparently also an ID photo of a young boy. On the right of the picture is an ominous dark shape which on closer perusal is revealed as a duplicate of the boy's image, only upside-down. The photograph's somewhat crude black-and-white quality carries romantic but disquieting overtones. Is this an orphaned refugee or simply a worried schoolboy? *No.75, Berlin, May 1990* shows a man and woman reflected in a mirror. The man's hand rests on the woman's shoulder in a proprietary,

even sinister manner. He is smiling. She is not. A series of cosmetic containers project phallically up from the bottom of the photo. To the left of the mirror hangs a wooden bamboo rod. Are we looking at a married couple or two lovers horsing around the bathroom, or was this document created by some psychotic snapshooter in preparation for something far worse than a few playful Polaroids?

Walter Benjamin observed that Atget photographed the deserted streets of Paris like the scene of a crime. In contrast, Schmid's 'street photographs' are full of people. Yet the abrasions, bleached colours and missing parts lend them the eerie aspect of evidence entered in support of a story written somewhere else, by parties unknown. Intervening in the life of these images, Schmid has recuperated each one as a postmodern testimony to the extended imprint left by photography on the modern city and modern life. Beyond that, *Pictures from the Street* also tells the story of his own peripatetic urban wandering as lecturer, teacher, artist, critic – and image scavenger. Each picture is titled according to the time and place it was found, thereby serving as a route-marker in Schmid's journey as international *photo-flâneur*.

In this sense, Schmid is indeed the *auteur* behind *Pictures from the Street*. Yet by including every photograph he finds, Schmid deliberately explodes the notions of personal style and (self-)expression that we normally associate with photo authorship. These photographs are riddles cast out from the lives of the people they depict, and their secrets have nothing to do with Joachim Schmid, conceptual artist and one-time photographer. Each picture represents a tantalising narrative the viewer can sense, but not reconstruct. This in turn points to the peculiar dual register on which *Pictures from the Street* operates: simultaneously a sophisticated commentary on our obsession with photography, and a collection of images visually seductive in their own right.

Although they must have had makers – the photobooth, the boyfriend, the grandmother, the commercial hack – none of these images possesses the kind of self-conscious meaning which we associate with fine art. It is easy to imagine likely reasons for the *taking* of most of the photographs, but that speculation is confounded and destabilised the moment they hit the street. For example, we know more or less why people make vacation photos of their children. Why they might tear them to pieces and throw them away is far less predictable, and a lot more interesting.

In contemporary art, including art photography, the attraction

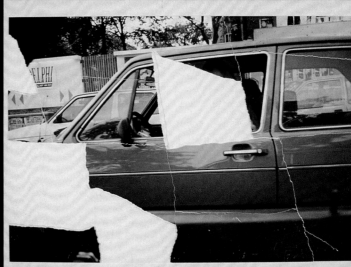

of vernacular photography is precisely its presumed, seemingly unmediated connection to life beyond the gallery. In a word, we read snapshots, like ID photos, photobooth pictures, and party Polaroids, as signs of authentic experience. Against the numbing hyperreality of television, the constant bombast of advertising, and the overheated special effects of the new Hollywood, vernacular photographs suggest a world that can be taken at face value, a world that appears unpremeditated and reassuringly stable, almost quaint.

Andy Warhol once commented that: 'An artist is someone who produces things that people don't need to have but that he – for *some reason* – thinks it would be a good idea to give them.'[1] In contrast, none of the anonymous litterbugs who made these pictures intended to give their handiwork to anybody. But in 12 years of dedicated strolling through four continents and more than 40 cities, Schmid has proven a sharp-eyed salvager of their photographic flotsam. The result is a genuine *Salon des Refusés* – an anti-museum of throwaways, and an archaeological sweep through the streets of modern life. Simply by picking up what other people have dropped on the ground, Joachim Schmid has compiled a sprawling, evocative, disturbing, hilarious, utterly familiar, yet uncanny *Gesamtkunstwerk* of simple means and surprising depth. In refusing to play the *photo-auteur*, Schmid has told a far more ambitious story about the life and afterlife of photographs.

Excerpted from 'Joachim Schmid: Anti-Auteur, Photo-Flâneur' in Bilder von der Straße, *Edition Fricke & Schmid, Berlin 1994.*

Notes

1 Andy Warhol, *The Philosophy of Andy Warhol*, Harcourt Brace Jovanovich (San Diego and New York) 1975, p144.

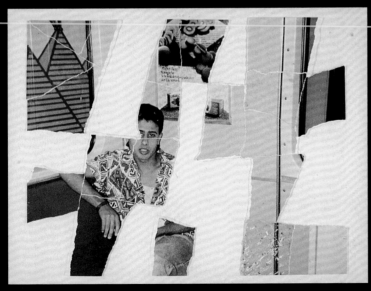

OPPOSITE, ABOVE L TO R: No.140, Belo Horizonte, August 1992; No. 192, São Paolo, October 1993; No.187, São Paolo, September 1993; No. 83, Berlin, July 1990; *ABOVE:* No. 108, Berlin, July 1991; No. 151, Berlin, September 1992; *photographic media*

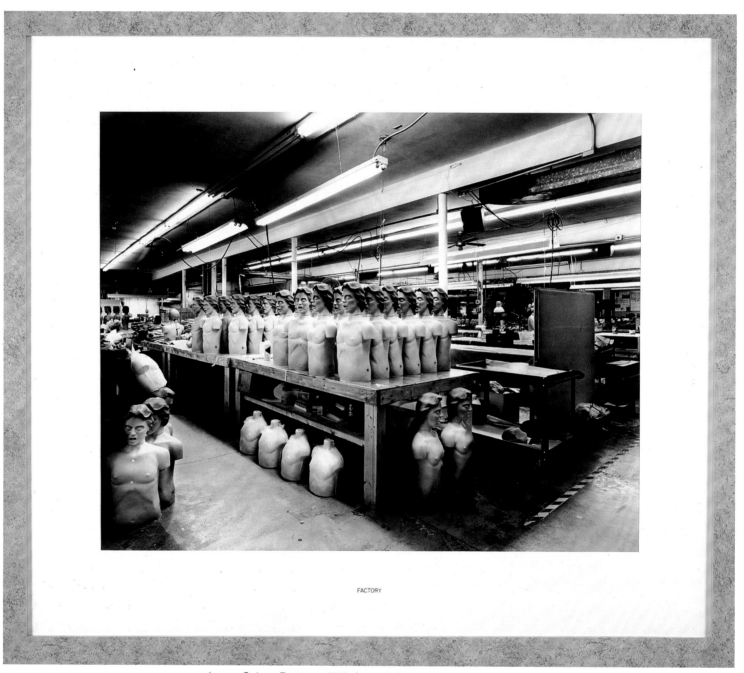

FACTORY

Lynne Cohen, Factory, *1995, framed silver print with text on matt*

THE MISE-EN-SCÈNE OF THE EVERYDAY

SUSAN BUTLER

Worlds of Interiors. Many kinds of interiors – within the humanly shaped space of the built environment that has become, in effect, our second nature, the guise in which the world presents itself to most of us. Picture some of its spaces: offices, shops, hotels, hospitals, restaurants, training centres, laboratories, classrooms, factories and museums. Neither so intimate as the domestic, nor so anonymous as the street, these are the sites of interchange beyond the immediate confines of the family, the spaces of producing and reproducing our goods, our social relations and, to a considerable degree, ourselves in the late 20th century.

Over the past decade and a half, a number of photographers have turned their attention to this sphere, this social landscape of the constructed environment. As yet it is difficult to tell whether this marks the emergence of a new genre, or perhaps a subtype, continuous in some way with broader concerns of contemporary landscape photography. That genre, however, is one which, over about the same period of time, has been radically redefined in its aims and methods. In a very general way, both these areas of work could possibly owe something to the fact that at this point in history, it is difficult any longer to imagine an 'elsewhere', any space still untouched, undetermined by the human interventions embodied in global communication networks, geopolitical upheavals, ecological crises. In light of this, it is not surprising that photographers should attend more closely to specific contexts of the humanly wrought world.

However, this interest in social spaces of the architectural environment may owe relatively little to established genres within photographic traditions *per se*, given that its practitioners often come from the side of art-practice, or from photographic training with strong conceptual links to recent modernist traditions of art-making.[1] The foremost practitioner in North America is Lynne Cohen, formerly a sculptor, and in Europe, photographers such as Candida Höfer, Thomas Struth and Andreas Gursky who have all studied at the Kunstakademie in Düsseldorf under Bernd Becher.

Since the 60s Becher, working in partnership with his wife Hilla, has produced the now-famous serial photographic images of industrial structures such as pit-heads, water towers, blast furnaces, etc. Perceived early on partly as studies of vernacular architecture, these images, through their subject matter, could be associated conceptually with a Duchampian notion of 'anonymous sculpture', while the method of picturing, emphasising regularities or repetition through a consistent viewpoint of similar structures within images shown as multiples in a grid, had resonances with serialist preoccupations in minimalist sculpture.[2]

This typologising approach has been even more influential than the Bechers' specific choice of subject matter, for it adumbrated a photographic stance elaborated through the 70s and 80s in their own and others' work that has arguably relocated straight photography as a highly significant practice within contemporary art production. Cool, detached, deadpan, at once canny and uncanny, this stance derives from effects quite specific to the typological or archival approach which structures – and creates – meaning in a particular way. In this context, as Gregorio Magnani points out:

> Meaning undergoes a circular series of displacements that transfer significance from a single image, to a comparison between similar images, to the overall project that brings the images together, to the conditions that produced the project as they are instanced in the individual images.[3]

Also important is the distancing or muting of authorial presence – achieved here through tactics radically different from those of postmodernist practice, which tends to exploit the promiscuity of photography, deploying the copy-cat facility of its index to quote mass media images from a range of sources. The archival approach is, rather, shrewdly puritanical, relying on indexical descriptiveness in the external world to the point that systematic description itself becomes symptomatic – both in relation to what is described and in relation to a certain will to acknowledge that becomes evident through repetition. Thus repetition reveals photographic vision as highly structured and not therefore transparent, natural, or even, ultimately, objective – despite its indexicality, which may be operated as a kind of insistently 'dumb' performance. It is left to the spectator to construct possible meanings through comparative viewing.

Such factors also distance this practice from traditional documentary photography which can seem relatively melodramatic in its 'human interest' subject matter. The traditional documentary series tends to chronology in the telling of a story; by contrast, the archival series is synchronic rather than diachronic, its units or instances to be read across, more or less indefinitely, rather than sequentially. This strategy maximally exploits the intrinsic photographic function of displacement (upon which the spectator's act of comparing depends), showing side by side structures or places that are geographically separate and not otherwise visible together.

Although such an approach obviously risks monotony, it is susceptible of internal shifts in strategy which produce revealing

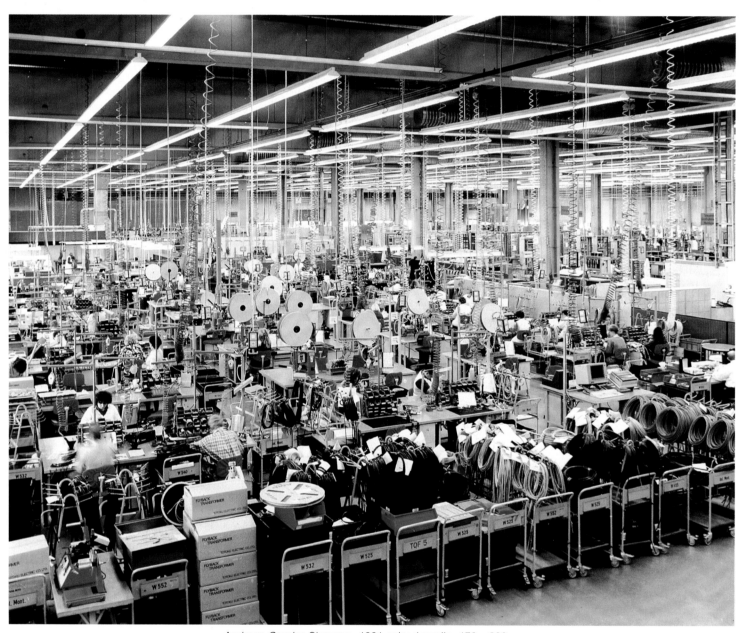

Andreas Gursky, Siemens, *1991, mixed media, 170 x 200cm*

inflections within particular bodies of work. Of the photographers discussed here Lynne Cohen – though more isolated in context – is perhaps the most systematic. Compared to the Bechers, Gursky and Struth have evolved more mixed practices, working across boundaries of genre and subject matter, while Höfer's subtly unassuming approach admits a subjective element potentially heretical to the very notion of archive.

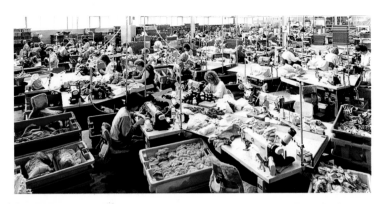

However, Cohen's more consistent adherence to a rigorously minimal approach through greater regularity of framing and the use of black and white yields effects that are strategically revealing in relation to the rooms she photographs. These are contemporary spaces, often fabricated from synthetic, mass-produced materials. The ubiquitous reappearance of these man-made elements becomes especially apparent through the fine detailing of surface features. Indeed, the fabrication of a world of mere surface is precisely what Cohen discloses, blurring notions between the possibility of any pure, given 'real' and the fictional. It is not surprising that her images are often taken to be set-ups, although her sole intervention is that of photographing. Yet this act establishes a crucial relation in viewing insofar as the single-point perspective of her view camera, creating a more extreme perspective than that of the human eye, gives her rooms the angled proportions of stage settings, making them legible in these terms. Her decision to photograph them as empty spaces adds to the camera's effect of arrest or suspended action. The rooms become more easily intelligible as sites constructed for certain behaviours and activities – in effect, representations of possible sets of pre-existing social narratives or imperatives.[4]

Bereft, these spaces remain haunted by human presence – often through the stand-in of dummies or diagrammatic representations of the figure which she discovers in locations such as spas, salons, laboratories, or most ominously, a police training academy. More often items of furniture and their placement within the room recall human proportions and relations. These mere ciphers or echoes of human presence seem to reflect the sensory and spiritual depletion of the spaces, as if they can support no more than a regimented, cardboard existence, the remnant of a lost subjectivity. Cohen's pictures implicitly mock the sham individualism of contemporary culture.

Given these implications, such work could be merely grim, but the sharpness of Cohen's selectivity tends to imbue the images either with bizarre humour, or an eerie chill. Woodland scenes, geese in flight, glittering city skylines all turn out to be so much wallpaper; anything with leopard spots and four legs is sure to be a fake-fur covered chair. In her most recent work which emphasises coolly clinical environments like laboratories and spas, it is possible to imagine that if one entered these places, one might re-emerge with a rather different set of bodily appurtenances from those one arrived with. In the world Cohen pictures, no identity, of whatever kind, is safe any longer.

An interest in fabrication, in the sense of mass production, is evident in Andreas Gursky's photographs of industrial interiors.

FROM ABOVE: Andreas Gursky, Steiff, Höchstadt, *1991, mixed media, 170 x 200cm; Candida Höfer,* Castello di Rivara, *1989*

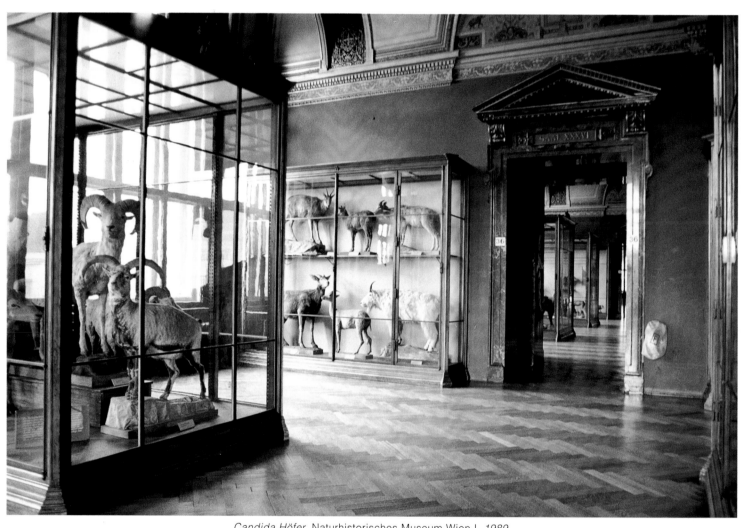

Candida Höfer, Naturhistorisches Museum Wien I, *1989*

These are also very contemporary spaces, but much vaster in scale than the claustrophobic, box-like spaces that Cohen frames. The formal simplicity of Gursky's slightly angled framing, often located at a high viewpoint, as in traditional landscape photography, emphasises sweeping terrains of complex but highly ordered arrangements of industrial equipment, attended by workers whose presence is all but swallowed up by the surrounding apparatus.

Gursky's use of the very large photographic print (about 150cm by between 180-240cm), now a cliché of photographic 'art' presentation, seems newly, and critically, relevant to the spaces and experiences he records. There is something excessive in the expanse of detail which is captured by the camera but exceeds the human eye and imagination. One is caught in a visual dilemma: going in close to examine specific detail means losing a sense of the field which becomes a massive overwhelming blur, while stepping back in an attempt to view the field means losing the capacity to bestow careful attention on any one person or thing.

In the context of the factory images, this difficulty in the very act of seeing lends itself to interpretation as a possible metaphor for the nature of social relations in mass culture. At the same time, it suggests limits of human vision and knowledge even though the photograph typically functions to extend and verify powers of human knowledge. Yet to ascribe these possible effects to specific authorial intention would be risky. One can only observe that particular strategies create conditions for producing certain readings. Gursky's looser relation to an archival structure expands, in fact, comparative possibilities, as he works across wholly built, industrialised interiors of the workplace, to outdoor landscapes showing varying degrees of human structuring or intrusion. Increasingly, as one looks back and forth across these spaces, it becomes possible to observe just 'how commerce has reshaped the natural world into a compacted, ordered and sterilised world'.[5]

But perhaps what finally emerges is the sense in Gursky's factory pictures of a kind of industrial sublime, in ironic relation to the natural sublime – a concept increasingly difficult to sustain, yet still doomily resplendent in *Aletschgletscher, 1993*, Gursky's monumental image of a mountain glacier. To turn again to *Steiff, Höchstadt, 1991* with its interminable interior landscape of sewing machines, showing women patiently at work between these machines and large bins of ready-to-sew cuttings of fake fur fabric is to apprehend how far we have now appropriated nature, or its effigy in the form of the toy stuffed animal, to our most intimate needs of subjective investment.

In their photographs of museum interiors, Höfer and Struth confront generally much older social spaces, and this choice in itself suggests a sense of the historical, punctuated by the camera's momentary interrogation of what we can make of this now. Höfer's and Struth's investigations of this context are revealing in different ways. Hers is a long-standing one, encompassing various kinds of museums including museums of natural history and zoos. It is part of a wider contemporaneous exploration of institutions of learning (universities, lecture halls, libraries, etc) which emerged from her earlier work concerned with informal meeting spaces such as cafes, restaurants and theatre lobbies. Struth's involvement with museums is intentionally more limited, occupying an area between his work on exterior urban sites and his portraits. He states that after spending time in museums studying portraiture, he 'started to wonder what people could still read in any given piece of art, if they could read anything at all.'[6]

Perhaps Struth's primary interest lies in this relationship more than the spaces as such, although these are inseparable insofar as it is primarily the museum which offers spectators the privileged subjective experience that the viewing of art supposedly provides. The formal grace of Struth's pictures (made with a large view camera) incorporates serendipities which subliminally tempt hope in this direction. A woman with a push chair in the Art Institute of Chicago looks as if she might more than just imaginatively enter the broad avenue of a Parisian street scene by Caillebotte, and two spectators standing either side of a large Renaissance painting in London each unselfconsciously reproduce a stance like that of the central Christ figure. These apprehensions are counterpointed in a view of the hubbub of a large crowd in one of the Vatican's tiny Stanze di Raffaello, and in the pictures of dozens of weary visitors to the Louvre, some resting on banquettes, attempting to contemplate rows of paintings displayed literally by the mile. Through notations of a range of responses from rapt attention to bewilderment or indifference, one is made aware that our experiences of artworks never exist independent of complex conditionalities – including the structuring influence of those institutions whose august formalities of architecture and presentation Struth's camera captures so well.

If Struth's very large prints address his audience through almost life-size scale, emphasising a series of rhyming, framed presences – the spectators in the gallery viewing a Struth photograph which shows spectators viewing paintings that in turn depict human figures – Höfer's pictures address the viewer through modest scale structured in a particular way. Her small prints (roughly 35 x 50cm) derive from her use of a hand-held 35 millimetre camera, equipped with a lens approximating the natural scope of human vision. In contrast to the heavy view camera and its typically lower angles, this not only allows for viewing the space at a normal eye level, it can also reference possible movement through it. Höfer's photographs thus gain a subtle but seductive fluidity, while inscribing a sense of human scale and proportion in the visual structure of the image. Like Cohen, she pictures the chosen spaces as empty, emphasising the address of the space to each viewer/entrant individually. Photographed in colour, Höfer's spaces are shown as more hospitable – there are glimpses of windows and doors, the filtering in of natural light. Her de-centred framing characteristically places the viewpoint at the natural point of entry, as if at a threshold.

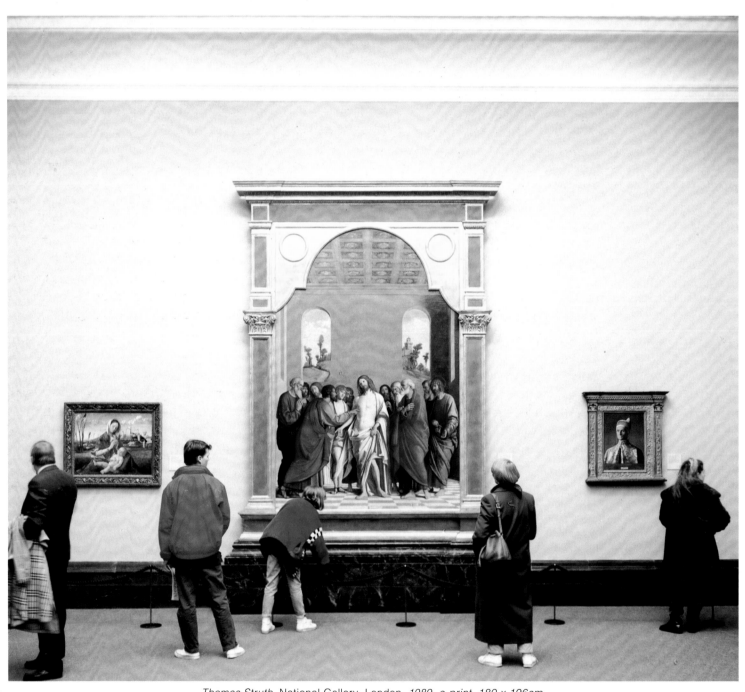

Thomas Struth, National Gallery, London, 1989, c-print, 180 x 196cm

This distance in relation to the space may be taken to indicate two distinct (though not entirely exclusive) modes of vision. It can suggest that fragile moment of apprehension when, upon entering a room, one takes one's bearings, registering intuitively a feeling or kind of social temperature about the place: but this distance could equally well imply a more anthropological sense of surveying the space itself, as opposed to the response of most visitors who would tend to zero in on specific displays or works of art within it.

Höfer's linking of the camera eye back to the greater spontaneity of the embodied eye places the camera's function in relation to subjective vision. Consequently, the camera does not simply index the scene before it, but marks an event of consciousness, in registering the image as the trace of a subjective perception and response at the moment it becomes the deposit of memory. Collecting images in this way is more closely allied to the personal motives of the tourist or amateur than to the systematicity of a more objective project.

Yet Höfer's retaining (however waywardly) of a loose class of sites also continues to reference the archival, not least because her selection prominently features those archetypal examples of the classificatory systems of the Enlightenment, the museum and the library, as well as other closely related institutions. By eliding subjective and objective modes of referencing, her practice illuminates the intersection of personal and cultural memory at the instant of photographing. That instant – as point of entry – could be taken as a broader metaphor for subjective confrontation with the Other and the individual's entry into culture – here implicitly characterised as a continuous, ongoing process. This reintroduction of the subjective is clearly couched in historical terms, but it bespeaks the possibility of discovering singular pathways through commonly shared terrains.

Or, as Magnani has observed, 'Höfer. . .portrays humanity as the space between abstract order and individual particularity.'[7] This observation assumes the 'space' (imaginative, ideological) of the human and of subjectivity as shared in important ways – ways embodied, for better or for worse, in the kinds of material spaces shown in the different bodies of work discussed here. Although Höfer's pictures afford a more suggestive glimpse of a concern with the subjective, something of this concern is more or less implied in the work of Cohen, Gursky and, more particularly, Struth.

There is then a kind of fruitful paradox in their approach which engages methods of ordering to disclose and critique a need for order at several levels, from the constituting of knowledge through to patterns of social regulation. These artists in turn constitute possible orders of knowledge themselves, building up not just taxonomies of places, but comparative visual structures in their respective sets of work which invite us to question the kinds, the qualities of relationship and effective experience fostered – or denied – within the social spaces they present.

Notes

1 Earlier precedents could be cited in aspects of the work of Atget and Walker Evans, although their images of interiors are primarily domestic. See 'Intérieurs Parisiens' in Molly Nesbit, *Atget's Seven Albums* (New Haven) 1992 and Walker Evans, *American Photographs*, 1938, (reprinted New York 1988).

2 Many of the observations in this and the following paragraph are indebted to Mark Friedus' essay, 'Typologies', for the publication accompanying the exhibition of that title that he curated for Newport Harbor Art Museum, Newport Beach, California, 1991 .

3 'Ordering Procedures/Photography in Recent German Art', *Arts Magazine*, March 1990.

4 These observations on Lynne Cohen echo in part my previous observations in *Shifting Focus* (essay and exhibition), Arnolfini Gallery, Bristol and Serpentine Gallery, London, 1989. Likewise my discussion of Candida Höfer draws upon that text, plus my essay, 'Points of Entry', published to accompany her exhibition organised by Art Project (Cologne/London) for f.stop, Bath and Anderson O'Day Gallery, London, 1993.

5 Peggy Cyphers, *Arts Magazine*, Dec 1991.

6 *Aperture*, No129, Fall, 1992.

7 'Ordering Procedures', op cit, with reference to the following paragraph.

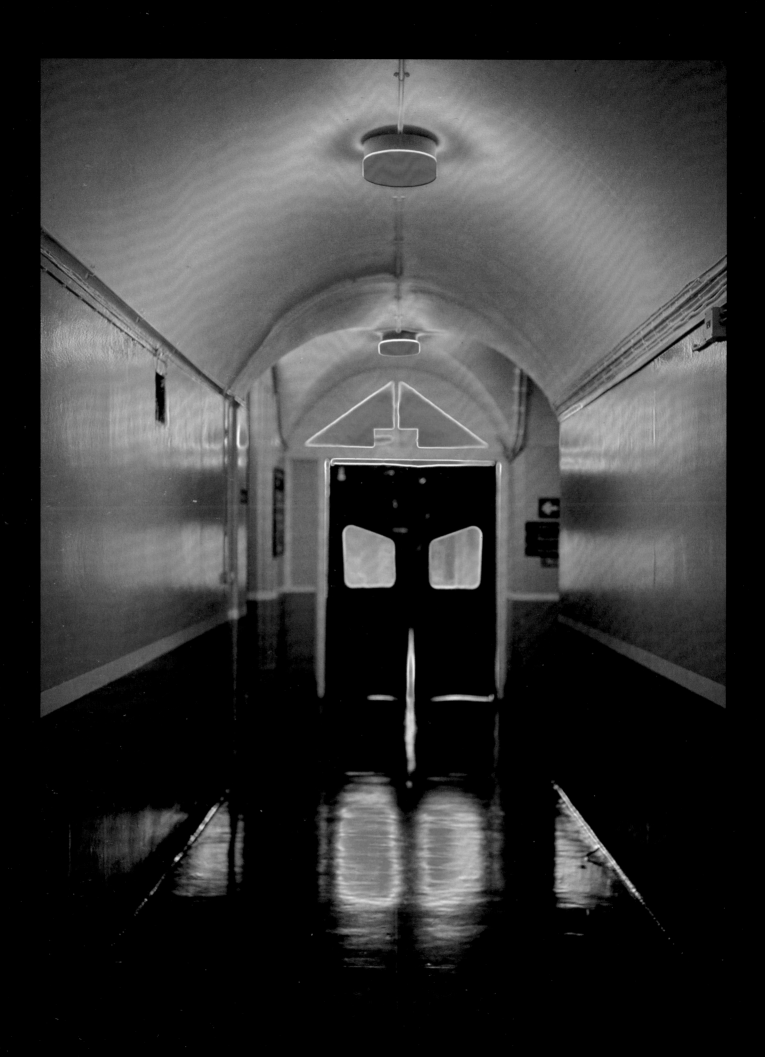

Springfield Hospital, a Victorian psychiatric institution in London, and were first shown earlier this year in the ICA's exhibition *The Institute of Cultural Anxiety*. The work is a response to Springfield's photographic tradition dating back to the work of a certain Dr Diamond in the 1840s and that of the better-known Francis Galton in the 1880s, both of whom pioneered photographic research into mental health in the name of 'scientific investigation'. After asylum inmates had been ushered in front of the camera to have their portraits taken, Galton would layer together several of the resulting negatives to produce a composite photograph which, he claimed, represented a generic image of madness, or the face of the archetypal 'lunatic'. The composites were filed away and categorised by type of illness such as 'mania', 'hysteria' or 'melancholia'.

The dynamics between institutional and personal identity are central to Yass' work. What is intriguing about *these* images is that though the artist is best known for her portraits, Yass has here made a conscious decision to exclude the sitter in favour of what was originally intended merely as a backdrop. The background claims a higher significance than that which we would normally expect to find in the foreground; in so doing, Yass turns Galton's, and her own, photographic practice inside-out, shifting the viewer's gaze away from the lens-pinned specimen to the immediate environment. Architectural interiors have a subliminal impact, and none more so than the corridor, a transitory zone with a beginning and an end. It is a picture embedded deep within the human psyche, the stuff of dreams and nightmares. From Ariadne's ball of twine guiding Theseus through the labyrinth to the virtual passageways of cyberspace, the corridor (or maze, or labyrinth) as visual or literary signifier is a pervasive presence in cultures past and present.

Yass employs a process of layering together positive and negative colour films within the same image, with further enhance-ghostly; the images are filled with a peculiar resonance as positive and negative, *yin* and *yang*, meet in symphysis across the surface, causing a semi-X-ray quality or suggesting architectural dissection. Strong light sources appear as solid blue, objects are blurred, light reflected off a wall appears as a shadow, a queer light emanating from a translucent, floppy plastic door gives the impression of a massive electrical surge; might we be looking through the eyes of a patient suffering the hallucinatory side-effects of heavy sedation?

It is the subtle shifts in our perception of nuances within architectural space that Yass explores through these interiors. At first glance they might be located indiscriminately within any institution, whether school, prison, hotel, laboratory, factory or government building; some appear comforting while others hold a certain dread. We are stuck in the middle – mid-corridor – neither here nor there, somewhere between entrance and exit. Their recesses, polished floors, oddly shaped windows and incongruous mixture of arches evoke emotional responses based on our own subjective memory. The idea of the photograph-as-record is undermined; what was there to start with and what is shown are very different things. The work is conceived as a series of large (88.9 x 71.1 x 20.3 cm) light boxes which form an installation within the 'real' corridors of Springfield. Here is yet another twist: by using the subsumed commercial properties of the light box to convey the cerebral nature of the images, we achieve a paradoxical fusion of the 'psychological' and the 'corporate', or an inverted and introspective form of advertising, to be viewed only by those that inhabit these strange passages.

The work was commissioned by the Public Art Development Trust for Springfield Hospital under the Art in Hospitals Scheme and was funded by The King Edward's Hospital Fund for London and the London Arts Board.

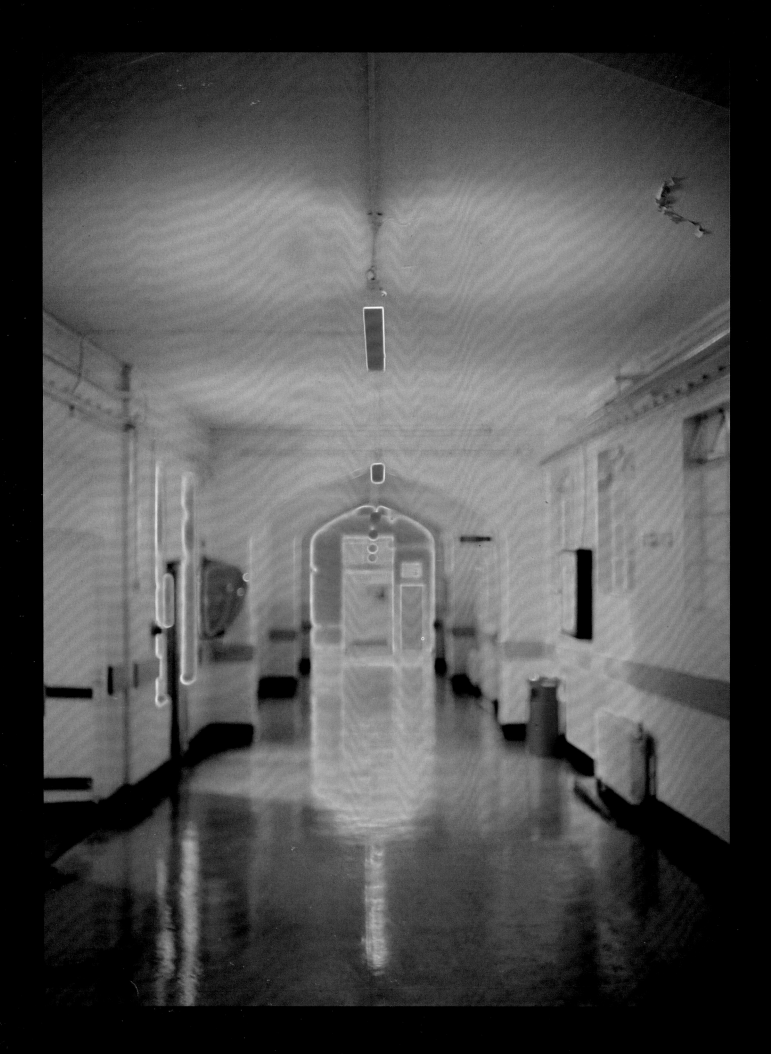

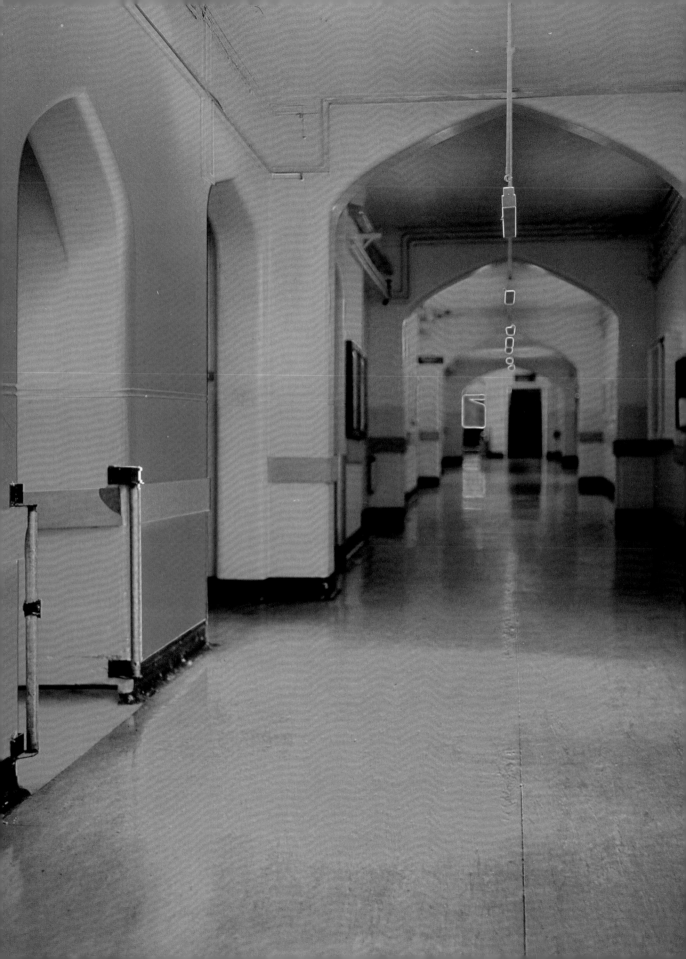

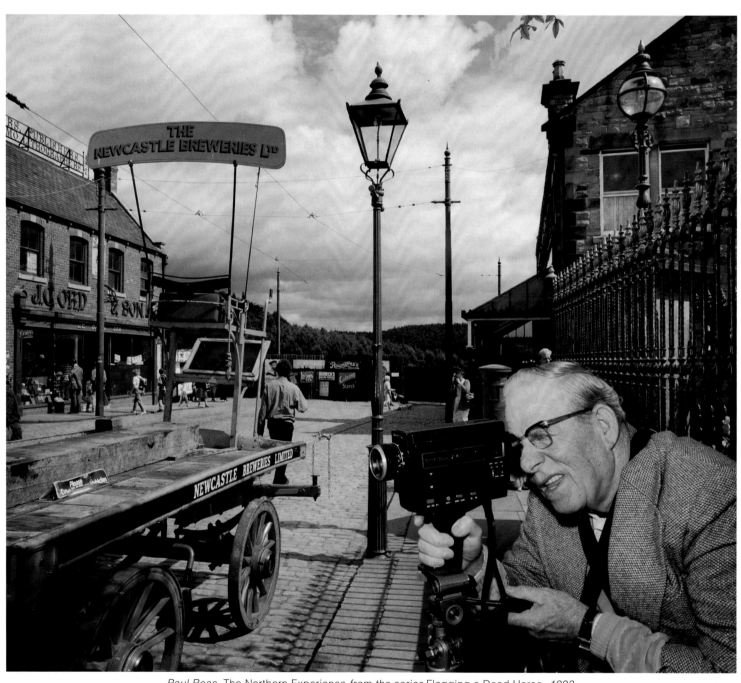

Paul Reas, The Northern Experience *from the series* Flogging a Dead Horse, *1993*

DOCUMENTARY FICTIONS?

IAN WALKER

In 1984, Alan Trachtenberg published an essay on Walker Evans' classic book *American Photographs*. He began by noting that when the book first appeared in 1938, critics 'assumed at once that the pictures represented a real and demonstrable America'. However, after an analysis of how the book actually constructs our view of its subject, Trachtenberg ended by calling *American Photographs* 'a fictive world, an America of the imagination: a documentary invention'.

In 1988, the British photographer Chris Killip published a book of his photographs under the title *In Flagrante*. It was at first sight a detailed documentation of working class life in the north-east of England, extending a tradition in British documentary which can be traced back to the 30s; Killip however had different ambitions for his work and in his preface, he wrote: 'The photographs can tell you more about me than about what they describe. The book is a fiction about a metaphor'. I'm not sure what a 'fiction about a metaphor' might be, but nevertheless, the intention is clear. 'Fiction' suggests that, once again, this documentary is an invention, and 'metaphor' suggests that this factuality actually means something else, something more to do with the author than his subject.

These two disparate examples suggest something of what has happened to documentary in the 80s and 90s, both in a reading of the history of the genre and in the intentions of its contemporary practitioners. Recent documentary has come to acknowledge that objective reportage is impossible, that every story is told from a particular point of view and indeed turned in that process into a 'story', a narrative imposed on reality; it acknowledges that 'history is told by the winners'; that photographs construct as much as they record. How then can we still believe that what we see is 'true'? For surely the concept of a 'documentary invention', a 'documentary fiction' is a contradiction which undermines the very basis of the genre. And if we don't believe in documentary, then what *use* is it?

On the other hand, the best work produced during the last decade does show that it is possible to combine scepticism about documentary itself with a continuing critique of shifts in society and culture. Indeed, I believe that the political power of this work has been all the stronger for that self-appraisal, without ever losing sight of the fact that in a post-colonial, post-industrial, post-modern world, it is imperative that we should not be very sure of ourselves.

I can't really illustrate this complex process with one picture; indeed, as I will argue below, documentary is surely no longer about 'great' individual pictures, nor even 'great' individual photographers. But one image which does suggest something of what I am proposing here was taken by Paul Reas at Beamish in Durham, one of the many industrial heritage museums which opened in the 80s – though a rather particular one, being almost completely fabricated from buildings brought from elsewhere. The sun is shining on Beamish, on the brewery cart, the iron lamp standard, and the tram lines that end abruptly at a fence covered in old advertisements. It's also shining on the memories stored up behind that fence, memories clipped from old copies of *Picture Post* and from GPO newsreels.

Of course, it's also shining on the tourists. In particular, one visitor occupies the front of the image, a middle-aged man in a tweed jacket who films the scene with his Super 8 camera (perhaps just a year or two later, even he will be using a camcorder). Whereas the scene behind is lit by the sun, this man is lit by the photographer's flash, making it look as if he's not *in* the scene at all, but rather in front of a screen on which it is being projected. The effect is physically the result of a particular photographic technology, yet it can also act as another sort of metaphor, representative of how we in our 'heritagised' age relate to our history, a history that, like Beamish itself, is often constructed as nostalgic scenery. We can no longer be in *there*; we stand out *here* and look at it, making our own simulacrum. The photographic conceit and the political meaning interlock completely.

There is, needless to say, a context and a history to this repositioning of documentary photography. It is parallel to very similar processes in other documentary media – notably film and television, but also biography and journalism – and related to the development of the hybrid forms of 'docudrama' and 'faction'. There are also parallels with other cultural practices whose history has similarly shifted from colonial certainty to post-colonial doubt, such as for instance anthropological fieldwork. But it has also developed out of a critique of documentary photography itself which was mounted most acutely in 1981 by the American critic and artist Martha Rosler:

> The exposé, the compassion and outrage of documentary fuelled by the dedication to reform has shaded over into combinations of exoticism, tourism, voyeurism, psychologism and metaphysics, trophy hunting – and careerism.

Rosler also coined a term which ever since has acutely pinned down the power relationship between photographer and subject: 'victim photography'.

There have been a number of responses to this critique. One

Gilles Peress, pages from Telex Iran, *1984*

has been to reassert the more positive moral and pictorial values of traditional documentary, a tactic followed by such distinguished photographers as Eugene Richards and Sebastiano Salgado. Another, opposing, tactic might be to admit that photographing other people is indeed exploitative, voyeuristic, and all about imposing *your* vision on *their* lives, but that the important thing is openly to acknowledge the fact. The prime British exponent of such a way of working, Martin Parr, has recently described his approach in such terms. Historically, it's what makes the images of *Weegee* so compelling; his 'smash and grab' tactics are completely up front.

However, there have, I think, been more subtle ways in which photographers have attempted to work around these issues, and some of the range of possible directions can be gleaned by scanning a couple of recent anthologies around documentary issues, one from Holland and one from Britain. The first was an issue of *Perspektief* published in 1991 and entitled 'Repositioning Documentary', while the second was a British Council touring exhibition curated last year by Brett Rogers under the title *Documentary Dilemmas*.

Both projects included work which was nakedly and overtly subjective – Nan Goldin's *Ballad of Sexual Dependency*, for instance, is completely in the confessional mode. On the other hand, both projects deliberately extended the concept of documentary to include work that might previously have been placed in another genre such as landscape. Undoubtedly, one development which emerged in the 80s was a shift in landscape photography from retrospective nostalgia to a reflection of contemporary cultural, social and even political issues. With John Davies in Britain, Thomas Struth in Germany, Richard Misrach in Nevada and Sophie Ristelhueber in Kuwait, landscape has proved itself capable of work in which the obliqueness of the commentary adds to its power.

Both bodies of work also included examples of the staged, image/text work that seems to be in opposition to documentary yet which often – as in the case of Karen Knorr who is included in both anthologies – draws upon and comments (once again, obliquely) on the power of documentary. It's also been important that other voices than that of the white male have started to be heard. Ingrid Pollard's black presence in the English landscape is important here (even if her images are in fact staged and manipulated), while 'Repositioning Documentary' included the work of the Chilean Alfredo Jaar, known for his lightbox installations, within which he uses his own 'documentary' images of Third World workers. (There's a fascinating comparison to be drawn here with the traditional treatment of the same subject by Salgado.)

Where else would one look to see the most persuasive examples of this new documentary? There are, as I've indicated, individual images which exemplify some of what I am claiming here. Its effects have also infiltrated into magazines, though often in a rather exaggerated form. But, by and large, these issues and tactics require a broader field on which they can be played out. So the photographic book, always been the most complex and enduring site of documentary photography, has in the past decade seen many innovations in both form and content.

I want to consider – briefly – three books, French, British and American, from the 80s and 90s. The earliest is Gilles Peress' *Telex Iran* from 1984. Peress is a major photo-journalist who has made powerful work in Northern Ireland, Bosnia and Rwanda; in 1979, he found himself in Iran as the Ayatollahs' revolution burst around him. Lost in another culture that he could not read, he did not pretend to understand it but just kept shooting pictures which expressed that position. The book is packed with images taken through car windows, through screens, images of images, images that are decentred and unstable. Also threaded through the book are the telex messages between Peress and his agency, Magnum: Magnum telling him to stay in there and get the pictures, Peress replying that he doesn't know what pictures he's supposed to be getting. At times, communication breaks down and Magnum can only ask '*Où est Gilles?*'

In some ways, *Telex Iran* looks like traditional black and white photo-journalism: gritty black and white 35 millimetre, the reportage of a committed individual in the midst of historical events swirling around him. Yet in other crucial ways, it is very different, for Peress does not pretend to have either the intimate understanding or the objective overview Western reporters are supposed to aspire to. If knowledge *is* power, then Peress doesn't know and hence has no power; he is just a visitor to the heart of the Other.

The second book, *Steelworks*, published in 1990, is by a younger English photographer, Julian Germain. Its subject is the County Durham town of Consett, which might formerly have been the subject of a traditional study of industrial, working-class culture. The steelworks closed down (though Kenneth Clarke doesn't seem to be aware of the fact) and as the book's subtitle says, the basis of Consett's economy has shifted 'from steel to tortilla chips'. So Germain's book is a study in the process of post-industrialisation, and the bright primary colours of his photographs betray the pain of that process.

Germain's own images, unlike those of Peress, form only a part of the overall book, and they sit alongside other sorts of photographs: snapshots collected from local people, wonderful images made by local press photographer Tommy Harris, and a reprint of a 1974 *Sunday Times* reportage by Don McCullin, all belching smoke, tumbling slag heaps and grimy rain. Plus a range of texts by both outsiders and insiders. Thus, though the book's cover still says 'by Julian Germain', the project contains a plurality of voices, any single position is consistently questioned and it becomes clear that wherever one stands to look at the subject, there's somewhere else over there that would be equally viable. Thus, representation isn't reality, it can't be.

The third book comes from another, quite different context: the apparently comfortable ambience of middle America. Larry Sultan's *Pictures from Home* (1992) is, on one level, an intensely

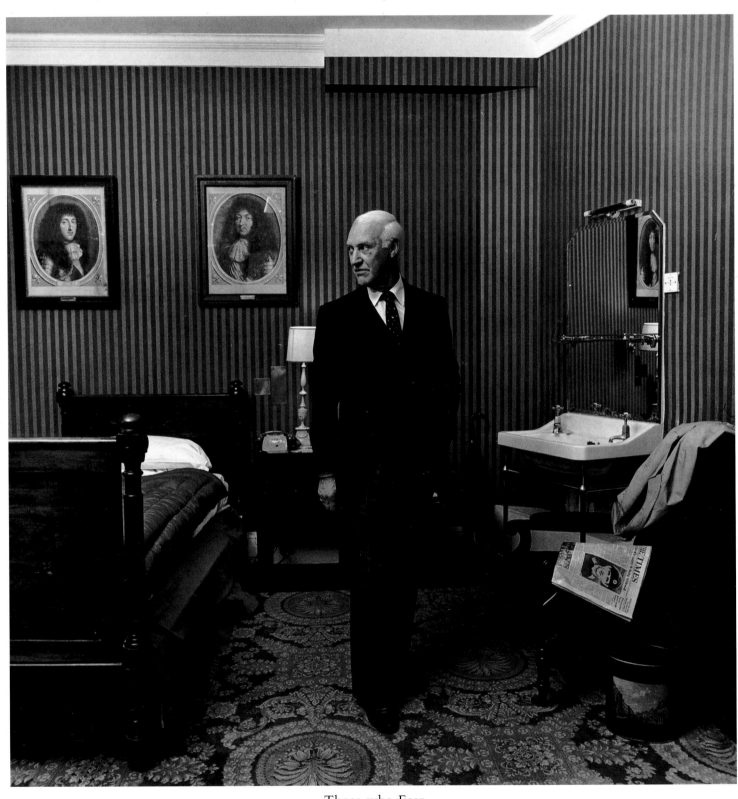

Those who Fear
the Rule of Women
but Love the Monarchy
should reconsider their Prejudice
to ensure the right
of his Firstborn to the Throne
will create a better Climate.

personal account of his relationship with his parents, particularly his father, a retired executive, and again it includes more than one voice. Sultan's own photographs and testimony are matched by those of his parents and – most potent of all – stills from their home movies, which depict, as such images always do, a world of joy and bliss at right angles to experience. At the end of the book, Sultan ironically comments, 'My father keeps asking me why I get all the credit for the pictures that he and my mother have made. It's a good question'.

There's more to the book, of course, than just a summation of the Sultan family album. Several of these images have been included in a number of recent photography exhibitions, including *Pleasures and Terrors of Domestic Comfort* in New York and *Who's Looking at the Family?* in London, which have concentrated on the home, the family, themes explored by many contemporary photographers and artists. They suggest that the state of the nuclear family can be seen as a microcosm of what is happening in society at large, and that photography now might best address itself to the particular rather than the general. Thus, though it's never explicit (and it's important that it isn't so), the space between Larry Sultan and his parents might stand for that between pre- and post-Vietnam America.

Three books then, and not the only ones I could have chosen here. Three books, however, that might suggest the range of possibilities opened up by recent documentary. Three quite different subjects – Islamic fundamentalism, post-industrialisation in Britain, an American family – yet with certain elements in common. Searching rather than finding, none of the photographs claims a privileged position – other voices being constantly present – while the book format allows for an intense level of inter-textuality within which the photographs evoke, or invoke, more than they state or define.

But isn't it still the persistent factuality, the adhesion of the photograph to its source, that makes all this important? Isn't documentary still potent and moving because, albeit within this context of subjectivity and constructedness, it *documents*? And – so they say – isn't this now under renewed threat? Working on this text, I was arrested by yet another essay with a related title: 'Pedro Meyer's Documentary Fictions', in which Jonathan Green discusses new work by this Mexican photographer, formerly a photo-journalist, who is now making digitised images in which the level of adjustment ranges from the self-evident through the minimal to the illusory.

Maybe that new technology will, as it develops, change the nature of documentary. Maybe, as the most apocalyptic versions suggest, it will destroy it. Maybe the CD-Rom (as witness Meyer's own *I Photograph to Remember*) will come to replace the book as the prime form for the complex layerings I've outlined here. More likely, I think (though I can't be certain, any more than anyone else can), these media will stand alongside each other. Documentary will survive, albeit affected by newer possibilities, precisely *because* of the shifts it has undergone in the last decade. Ten years ago, I thought documentary moribund, about to collapse under the weight of formal exhaustion and ethical paradox. I don't think so now.

Bibliography

Julian Germain, *Steelworks: Consett, from steel to tortilla chips*, Why Not Press (London) 1990.

Jonathan Green, 'Pedro Meyer's Documentary Fictions', *Aperture*, No 136, Summer 1994.

Chris Killip, *In Flagrante*, Secker and Warburg (London) 1988.

Pedro Meyer, *I Photograph to Remember* (CD-Rom), Voyager (New York) 1991.

Gilles Peress, *Telex Iran*, Aperture (New York), *Telex Persan*, Contrejour (Paris) 1984.

Martha Rosler, 'In, Around and Afterthoughts (On Documentary Photography)', in *Martha Rosler: Three Works*, Nova Scotia College of Art and Design Press (Halifax) 1981; reprinted in Richard Bolton (ed), *The Contest of Meaning*, MIT Press (Cambridge, Massachusetts) 1989.

Alan Trachtenberg, 'Walker Evans' America: A Documentary Invention', in David Featherstone (ed), *Observations*, The Friends of Photography (Carmel, California) 1984.

Ian Walker, 'Desert Stories, or Faith in Facts', in Martin Lister (ed), *The Photograph in Digital Culture*, Routledge (London) 1995.

OPPOSITE: Karen Knorr, from Gentlemen (1981-1983), *66.7 x 56.5 cm*

FROM ABOVE: Julian Germain, Consett Bus Station: Built with Italian Steel, *from* Steel Works, *1990;*
Larry Sultan, *from* Pictures From Home, *1992*

NOSTALGIA FOR THE FUTURE

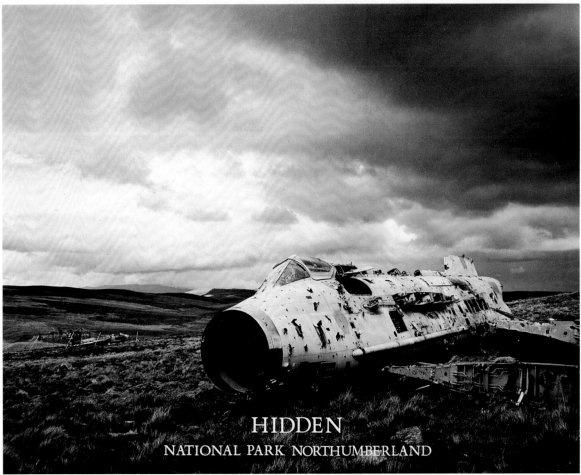

HIDDEN
NATIONAL PARK NORTHUMBERLAND

John Kippin, FROM ABOVE: Nostalgia for the Future, *North Seaton, Northumberland, 1988, 149.9 x 124.5cm;*
Hidden, *National Park, Northumberland, 1991, 149.9 x 124.5cm*

Paul Seawright, from Police Force, *1995*

Mari Mahr. Another Paragraph *from* On the Island

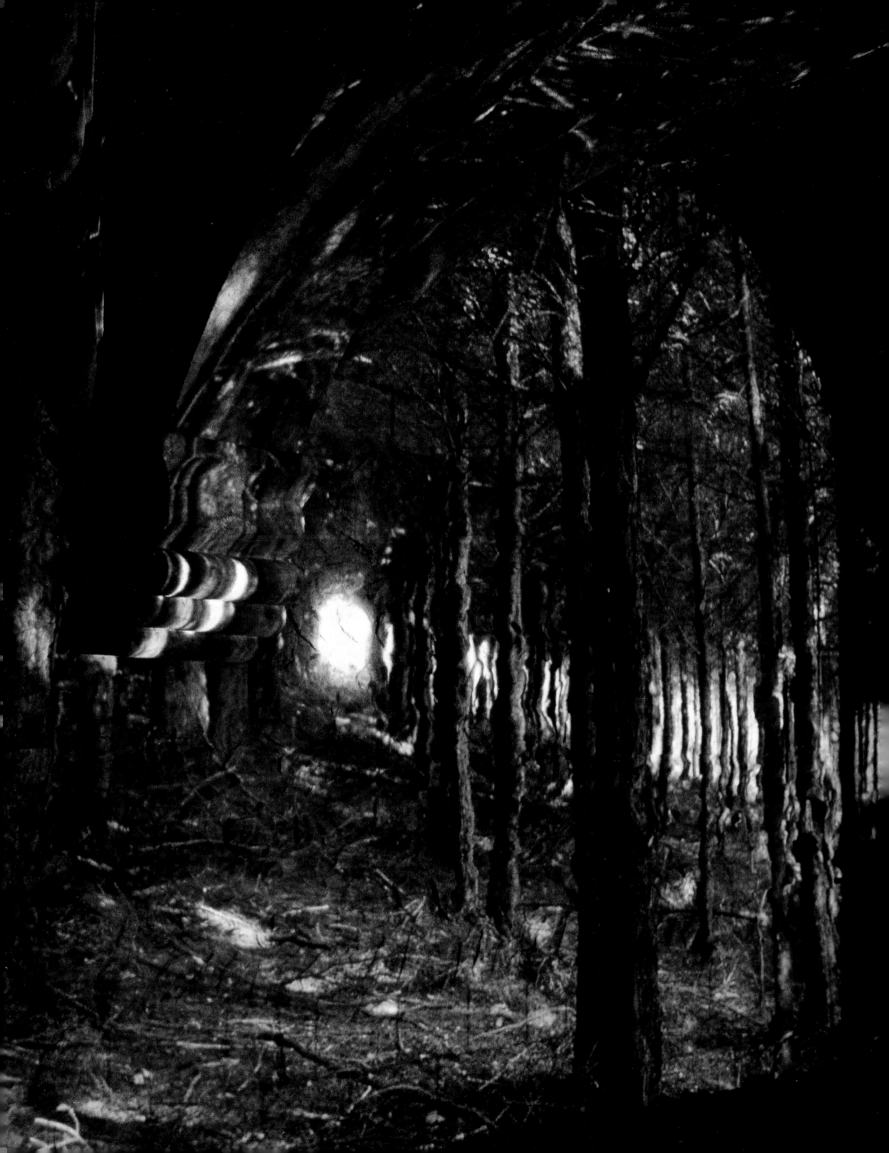

SUSAN TRANGMAR

LEWIS JOHNSON

It's not merely that we don't know for sure what a documentary photograph is, but also when it is. Barthes wrote, 'The photograph does not necessarily say what is no longer, but only and for certain what has been.' But this is to claim too much about what the photograph says, probably too much *that* the photograph says. Rather, each and every photograph may suggest that there has been something . . . photographed. Perhaps no more than this; and even this is not certain. To say what has been, especially 'only and for certain' what has been, when provoked by a photograph, is to treat the photograph as a document.

As follows? Susan Trangmar's installation *Amidst II* was staged in the crypt of the Monasterio de Veruela in the village of Vera de Moncayo in Spain as part of the 1994 Tarazona Foto Festival. Transparencies projected by slide projectors on stands positioned, as in *Amidst I* at the Dash Gallery, London earlier that year, around the perimeter of the room, casting images of a forest on the walls and pillars of the building. Images which, re-photographed, enable once more something of the space of a forest to be imagined. But more than this, more than the recollection of forests like these, or any easy fantasy of the simulacral, there's the permeation of the projected images by their support. The rising and falling lines of the building and its surfaces, passing into and, if not becoming, then touching as if becoming the coloured light of the projected images. Neither the building nor the image with the monopoly of nature, the image here is not without such an effect: of nature, as a trace of that which has already been forgotten and yet will not be remembered.

Instead, in between, a rhythm. In the installation, there was the sound of the projectors, a translation of energy, electrical to sonic. What survives here is a certain patterning of the lights of the horizon: sites of projected paranoia perhaps, places from which to be seen, but there, and here, given another space. From which they may still appear to come at you, but without ever arriving. Thus from a space, in a building, or even in a magazine, which will not ever become an enclosed interior. Exteriority, even within an architectural space.

And next, the photographs of *Interval* which may (yet) deceive you. It may be that you're too close to notice whether the light illuminating the closed off waiting rooms from within is red to the left and blue to the right, or the other way around. Traces not only of the switching, but also, in the variation of the colours, of the intensification and de-intensification of the lights. Something seeps out from these two photographs of the changing of light, a seepage reiterating that which occurred at Tilehurst station last January and February; switched on between dusk and dawn, the changing lights from within the waiting rooms changed the very changing of the sun's light, a rhythm faster, then slower. Thus, the work suggests that there is not light but in its variation, its coming, a coming and going. As if to come again. And from the beginning. Time itself is thus the effect of this periodicity of changing spaces, reconfigured between the symbolised and calculable intervals of a timetable, as loss, beyond repair, and yet as intensity of duration.

Intensity, that is, of some desire or other. For all that there's no one in these images, and that they don't tell the whole story of the work – how could they – they're more than melancholic. Traces of systems of lighting: not co-operating to define a place, but to suggest dislocation of place, intersection of different system spaces. These photographs reassemble the work as the work of a body, assisted by a camera, assembling something to be seen. Artist as spectator, spectator as artist. And between the terms of these violent identifications, playing on the very mechanism of an archive of the work, we may once again remember the act of seeing as that which is forgotten in the look. Furthermore, to try and assemble anything for a look is to risk missing that something has gone missing: here, the abyss of the foreground of the images, the space of the tracks, space not captured in a system, though apparently dedicated to one, exceeding reach.

Remembering the shock of the passing of high-speed trains on the route from London to South Wales as they interrupted my sense of duration, I remember forgetting not just where I was, but that I had been. In between, an effect which echoes between the two images of *Interval* here, some ecstasy of place.

OPPOSITE AND OVERLEAF: Amidst II, 1994, crypt of the Monasterio de Veruela, Vera de Moncayo, Spain; PAGES 42-45: Interval, 1994, Tilehurst Station, Kent

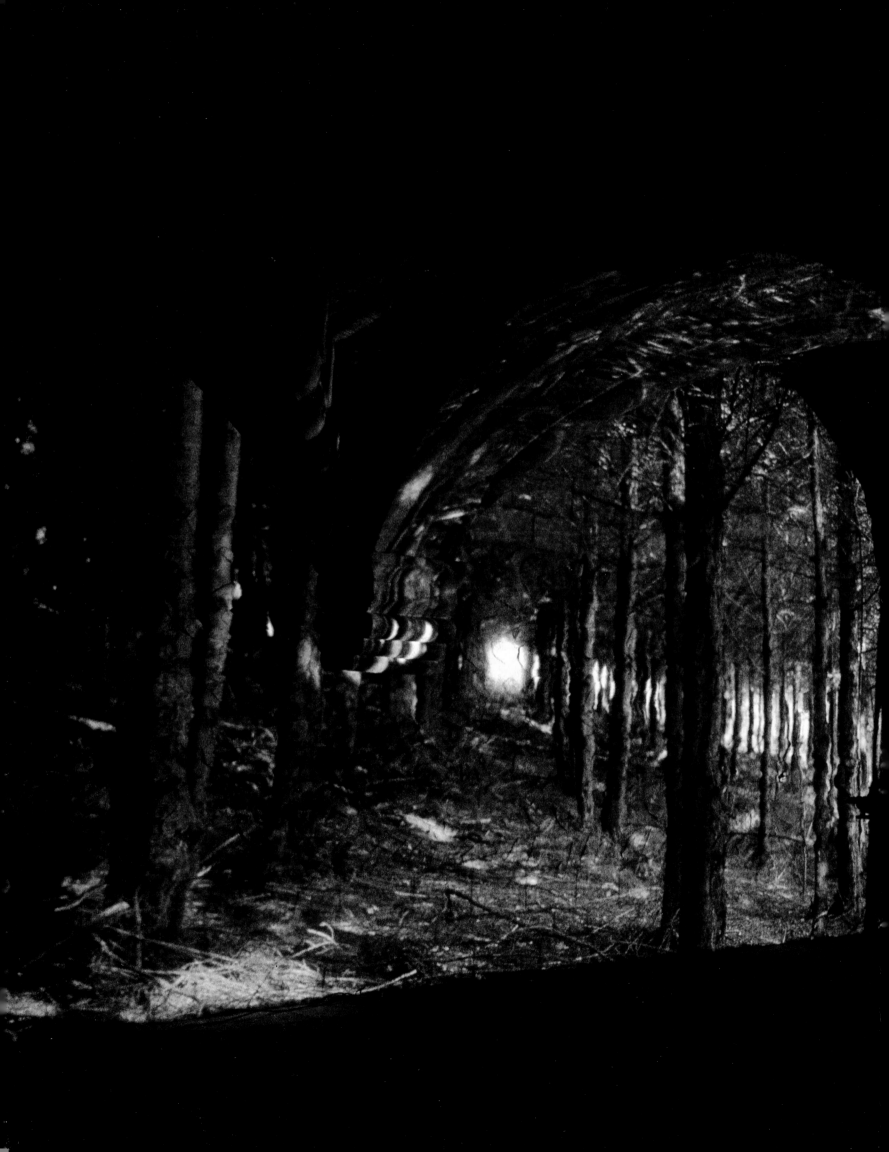

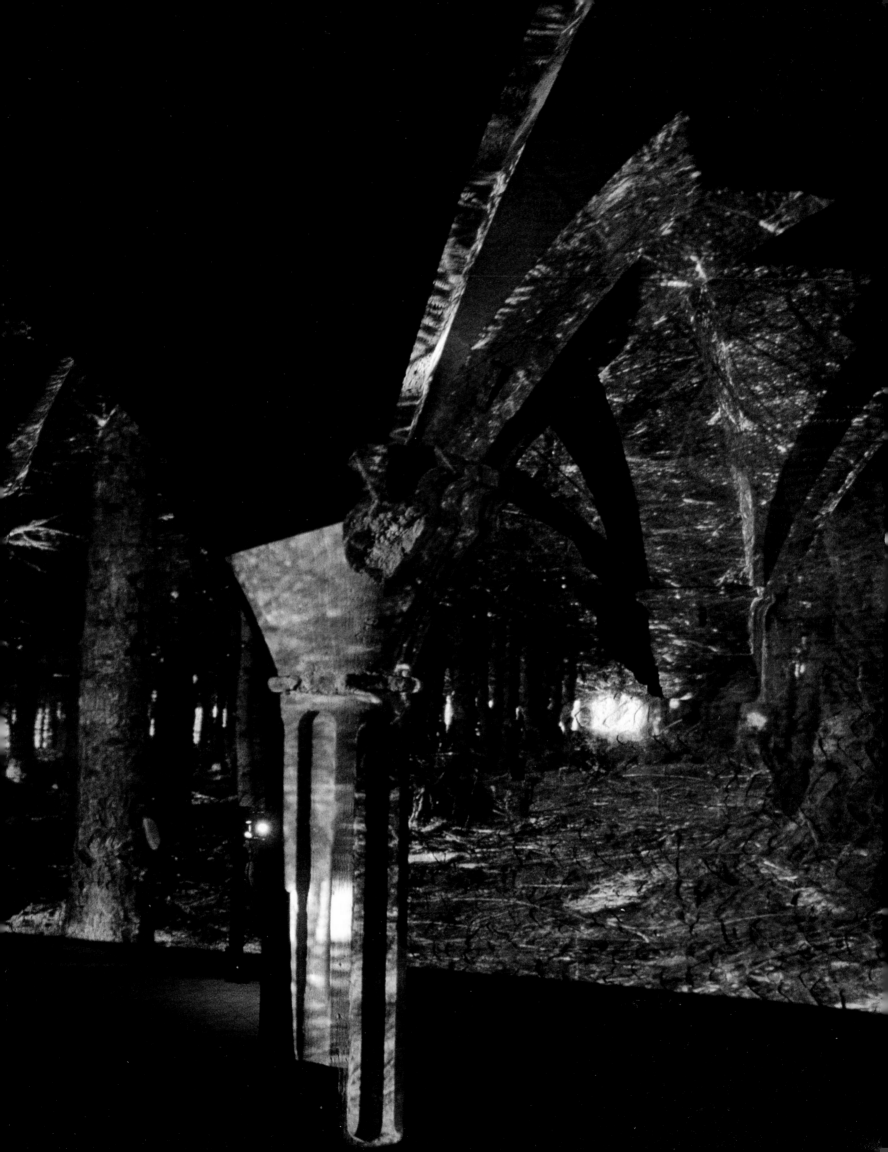

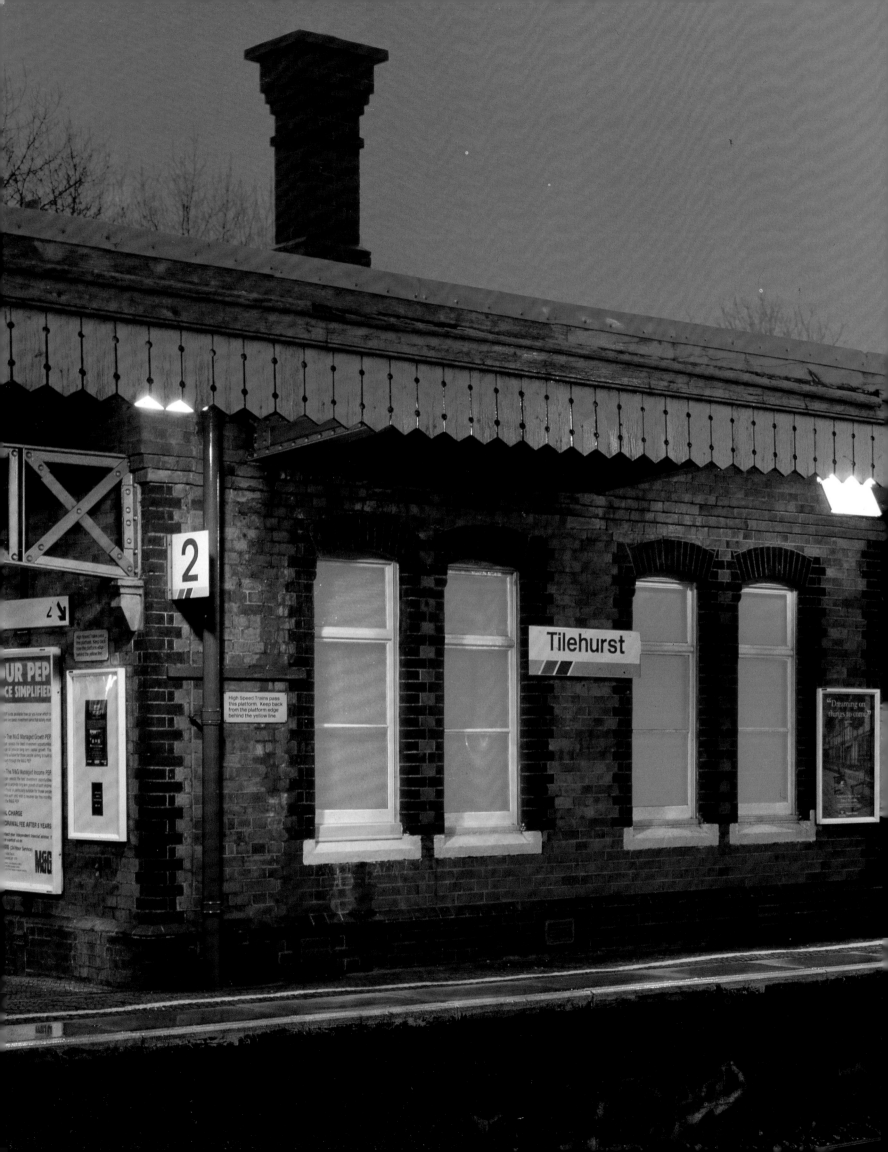

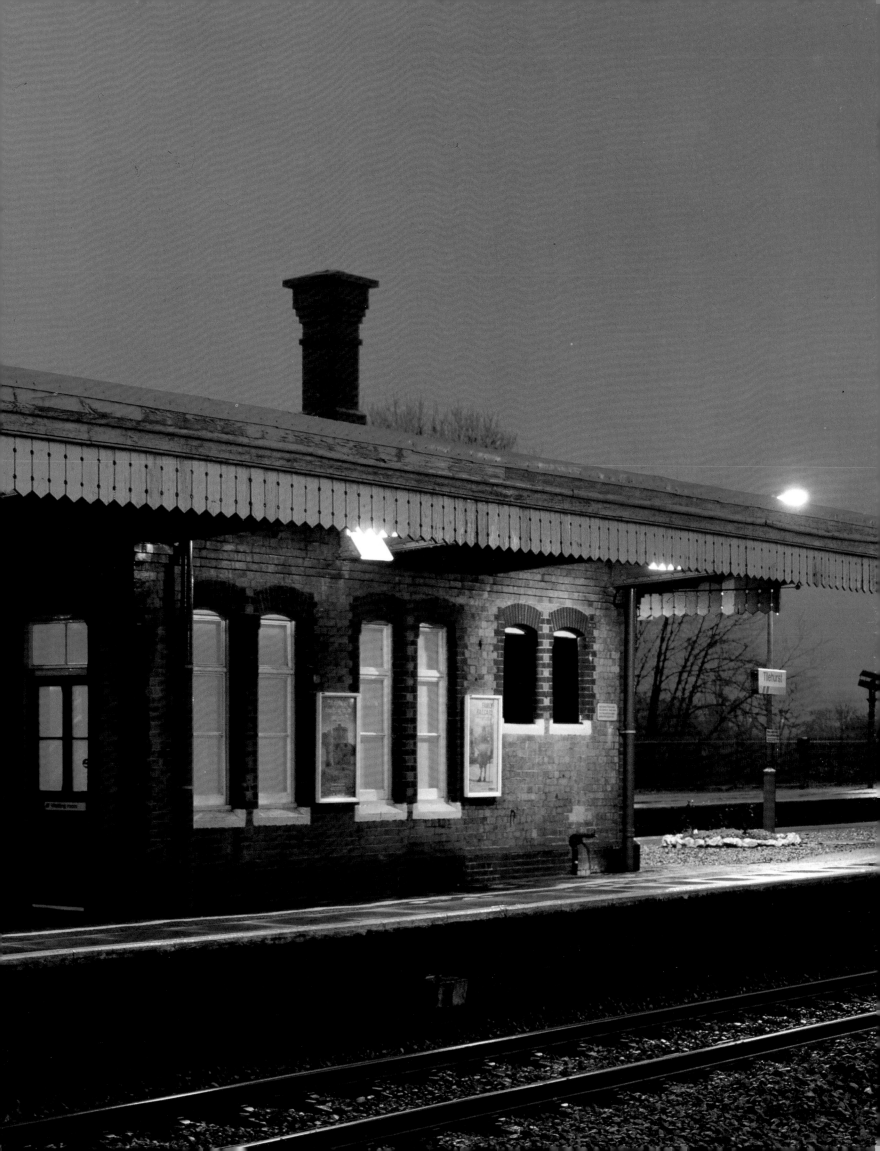

FROM ABOVE: Ania Bien, detail from Past Perfect, 1988, silver print; Elizabeth Williams, from Illuminated 5, 1983-86, silver print

THE SENSE OF TIME PASSING IN PHOTOGRAPHY

A PERSONAL READING OF TEN IMAGES

Clifford Myerson

Frederick Evans: On Sussex Downs (*c*1900)

Around the turn of the century, Frederick Evans photographed the Sussex Downs. To the right of the picture the Downs stretch away into a dark wilderness, a single black lump such as a palette-knife might have spread with bumpy depth and oppressive tactile strength. That is the land, and indeed impasto might have been in Evans' mind, for in 1900 photography borrowed heavily from art for authentication. A small clump of trees on the far hill holds the exact centre, and there is a road running up the left of the picture which might have been an exciting white slash with a sticky brush. It was not a painting, however: it was a landscape photograph, with the difference that it admitted a towering space. This space has altered the situation, for it is an imposing space, and one which impels the viewer to experience aloneness and his or her own completeness and singularity, and separation. In such a world you are a nuclear person, and the existential terms are fixed for you: in such a place, no help, and no hope, and no overriding contacts that will make the travelling easier. It is an ongoing journey, and time opens a cruel and impervious gap within the space so that the course can be completed, and then snaps shut, foreclosing on the life and its subjective condition as if it had never been.

Ania Bien: Past Perfect (1988-91)

'Put your hand on my forehead for a moment, to give me courage', Kafka said to Dora Diament as he lay dying. Ania Bien puts her hand on the forehead of the writer: a snapshot follows and is mounted close to another snapshot of huge buildings in a narrow lane, severe buildings with unfamiliar decorative lintels and panels, small towers and cupolas fading in the mist – Kafka's home ground, perhaps even the place where he died. Ania Bien is asserting herself to reach him, and relate to him, through a photographic assemblage that involves the two of them, with great personal intimacy and love. The artist says: I will not accept the time that separates us; I will not accept that time can fold our lives within it, and dominate us and our expectations: there must be room for a further assertion and expression of what is most myself and recognisably me, and my desires. She offers three shots of a woman's naked torso, hands folded over the pubic hair, as if both to give, and to restrain at the same time. Another building follows, tightly packed with windows, crossed by two white flashes of light. There is a script of childish writing, another one of the adult master's, and fragments from life that are unrecognisable. As the present is wedged into the past, a relationship which never was comes slowly and fragmentarily into focus, fraught with loss and finality and the sadness of what passes and is irretrievably lost, along with our most precious hopes and desires.

Robert Capa: Loyalist Soldiers Writing Letters (1936)

Two men sit comfortably in a hole they have dug while throwing up a bulwark against the enemy, who are on the way. A pick lies handy. This is the Spanish Civil War, the western world's war of conscience. The men are dressed in a nondescript way for work, which might include fighting, in a check scarf inside an unzipped jacket, a boiler suit. They are small, unassertive men, with rough beards several days old, and they would be inconspicuous anywhere except here, where their passivity and harmlessness are strikingly out of place. Yet for the moment they have given up the war, and all the great events in which they have been caught up, in an effort to deal with a problem which is beyond them. They are writing a letter home. One writes; one advises. Their expressions are relaxed and perhaps even faintly amused; clearly they take themselves lightly, and their everyday good humour is now compounded into humility, for they do not know how to write a letter home.

Their uncertainty and diffidence have now found a centre in the letter, and their concentration is complete. Through their efforts, glimpses of home appear, and we are driven by empathy with all we believe in to envisage these, look into them and take them on, too: some farmstead quarters beyond a trodden muddy yard, in an orderly countryside, a darkened kitchen, women's voices, laughter and good-natured teasing. The letter has drawn us out of the shot into the softened and meaningful world that is all our homes, and all our experience of trust and comfort; but time extends both ways and while we have been looking far beyond the tough set-up they have made for themselves, time slides forward through the photograph, too, and imaginary figures with bayonets come over the parapet. For this is 1936, and the two soldiers are on the losing side.

Elizabeth Williams: Illuminated (1983-86)

Sometimes it is easy to lose sight of the fact that black and white is not a realistic medium, but an art vehicle: nothing is less like life than black and white imagery this side of death. Furthermore, black and white areas have a tendency to become visually autonomous, and to hold their own local interest. Elizabeth Williams takes on these provisions. A forest stream with a

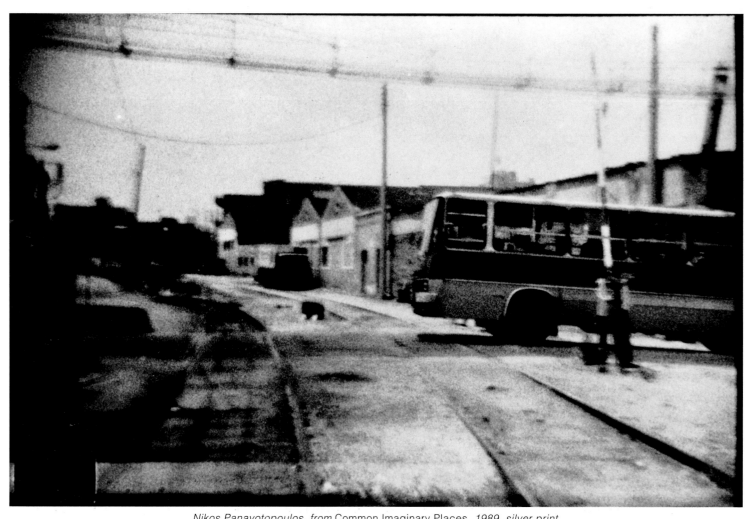

Nikos Panayotopoulos, from Common Imaginary Places, *1989, silver print*

flowered bank would ordinarily be visited for its cheerfulness. In this sequence, trees on the bank cast a shadow which falls across the water in a spreading black stain and broadens till it takes up nearly half the picture space in a concentration of feeling for which there is no obvious explanation. White patches glitter in this dark precinct, too bright and intense to be assimilated into the atmosphere of the stream. In the foreground, shadow and glitter encounter the sunlit blossoms, but all reactions have been played out. The artist threads through a succession of fiercely defined moods between which there is no connection, a despair and exhilaration for which the photograph does not account. In another sequence, *Through a Cycle of Time*, the camera picks out a space among the treetops. Spring buds dot the sky among gnarled branches; summer brings a coagulated encrustation of spiky foliage; autumn keeps a delicate balance until finally winter hollows out the scene, and a blankness remains which robs everything that has passed of meaning.

Robert Doisneau: Down and Out in Paris (1951)

Two people are emerging from the darkness of an embankment. Doisneau has given us the image of a man and woman who have reached the end of their time, and this is the predicament the photograph tackles: how to face an end. As it happens they amble on, out of habit. They have turned up in a condition where night may change to day, but for them time no longer works its separations between one event and another: an atmospheric residue is all that remains of the future, like an odour. It is the pointed image of people who have gone right through this life and find nothing to explain why they are there or what they were meant to do, and yet, their spirit survives. Doisneau throws a looming darkness round them, with a slash of light behind, in the distance, to emphasise that they are beyond and have left behind everything that can be shown or seen or recognised. A blankness occupies the space ahead, featureless, bland, indifferent; the photographer gives the putative space before them some weight, the weight of existence. We can spot the darkness reflected in their eyes, and the shadowy possibilities of happening within, that will miss them, because they are beyond involvement. His formidable self-defences have closed in round them and cut them off.

It is the plainest portrait of humanity facing adversity with resources that have no name: they are the means of the spirit, of some interior vision of the completed self, from which nothing can be subtracted, that central pivotal presence in a person which we name soul. We do not know what we are looking at, we do not know that we possess it, this centre of unworldly qualities, but we see it in the photograph, awesome in its defenceless state: the differentiated elemental person, showing an awareness of self which continues after comfort, hope and personal history have all run out, inseparable from the image Doisneau gives us of a flat face and flat moustache, as if the man's features were squeezed up against the picture surface, a contortion that has driven out feeling and apprehension. His hair bunches out of

a beret ballooning off the back of his head, his chin bulges forward with determination over the knot at his throat, or else he has no teeth left. The coat has lost touch with its origins and is now stiff with grease: clerical garb perhaps, or rainwear, or evening wear. The trousers are worn three-quarter length, tucked in his socks like plus fours, and the left stocking appears to be unravelling as if there might be a bandage inside.

She leans an elbow on his shoulder, for he is only about five feet tall, and lets him guide her as if she were blind. She is not blind, but takes nothing in. Somewhere along the way she stopped keeping a reckoning: none of what she saw made any sense, and now she leaves it all to him. Not that she has given up on herself and her own essential inwardness: in slippers, a flowered skirt or apron, signs of a one-time civility, she has outgrown the time and maintains a steady wavering silence, just as he does in gauche and uncompromising saintliness.

Nikos Panayotopoulos: Common Imaginary Places (1989)

Panayotopoulos' is an art, too, of mystery, but it is the mystery of childhood and first awareness and of encountering appearances for the first time. Adults often treat the photograph as a slice of life, which reveals an instant. Life perhaps was never like that: there is so often some dynamic rolling through the instant. Photographic representation is closely analogous to life but what mostly upsets the balance is the end-product in which contacts within the photograph are sealed and relationships fixed and frozen forever, a state totally unlike life where change is constant. From this point of view, the photograph can be visualised as a map with reliable boundaries, or a chart in which relationships are exactly located, sustaining the adult need for understanding, or at least control.

A child cannot indulge in such simplifications for the sake of sense, and has to accept the world in the way it is given. In the suburbs of Athens where he was brought up, using a disposable toy camera with a plastic lens which shows what may be seen in a map without proper credentials or precise boundaries, Panayotopoulos rediscovers this child.

A bus has climbed a slight slope and now extends into the shot under a raised beam guarding a level crossing: the railway lines curve away into a middle distance with factories on one side and shadow shapes on the other. Shadows are thrown across the space between by unseen objects. Shape and shadow elide, and there is no way of calculating distance; angles are smoothed away, gaps remain but vary according to the direction from which the eye approaches. Above, a cluster of cables strike straight across the top of the shot, so that looking upwards there are hints of another universe. We rely on the sloping bus to lever us into the picture, but within the scene the slippage is endless. Space and objects have to be separated and continually reassessed, but this attempt at an adult point of view leads nowhere except to the open-ended vision of childhood in a contraction of that time through which we have developed.

John Stathatos, ákea/atonements, 1995, silver print, 170 x 135cm

Robert Frank: Crosses on Scene of Highway Accident (1958-59)

In 1959, Jack Kerouac placed Robert Frank among the 'tragic poets of the world'. Here, the photographer's tragic view centres on a desolate setting, the world we are set in and pass through, within which efforts must go to making something of individual destiny, or to making more of it. He offers a background of plain shapes and gritty surfaces with no visual relief. A flat brushwood covers the hills like scurf. The road is a shaft through a landscape of stubbly grass clinging sparsely to stony patches – an uninviting world, the setting for a monotonous and unrewarding life and for some inevitable trouble within it. Three people are killed, and three crosses commemorate them. A radiant light falls from the hills above onto the crosses, glowing evenly over the landscape. Life fills with a glory in which we all share. Something which has been present all along behind the scenes has manifested itself under the pressure of events on our bruised nervous systems; but the incongruities persist, for they are set in terms of a romantic vision which points to other destinations.

Ralph Eugene Meatyard: Portrait of Man With Hat, Georgetown (1956)

In 1956, in Georgetown, Meatyard met a man whose life he summarised in a single shot. Of course this took magic. It was still early days for Ralph Eugene, but he already had the magic and never got any closer to understanding what it was. He turned his camera on a black man in a hat, and showed that when the black man was upset, he smiled; as surely as he is hurt, he smiles, but the picture is taken with a revelatory camera, which shows the process penetrating far back into the man's life, a thread along which that life has hung together. Every time he has felt hurt and hopeless, the smile appeared and transfigured the occasion, and transfigured him and the life around him. The revelation never fails. It is technical magic though, belonging to this particular photograph only, and works on the viewer, too, penetrating the viewer's past deeply and exposing the hurts and transgressions inflicted on those unable to protect themselves. One's own stock of decent responses has run very low, but there is no accusation; it is self-knowledge with which one is involved. Now he is very old. There is not much time left. So Meatyard has made a portrait that leaves a permanent impression which locks tightly in the mind, the black coat for protection, the twisted trilby for respectability, the spatulate hand thrown across the chest. Mind seems prepared for the image, as if there were a niche waiting for this figure in the imagination to immortalise him as surely as if he stood forever in some corner of a public square.

John Stathatos: ákea/atonements (1995)

With John Stathatos we enter a grove, a timeless place, and feel the heart-stopping awe with which we intrude into an area holding sacred meanings which are beyond us. The atmosphere is primitive and introverted. The glen is full of tiny trees or bushes, with a few stems that give no indication what the original shape might have been. The stems wind, twist and thrust, releasing a slow energy, coinciding with the artist's need for independence in a world of ready-made ideas and conscripted values, letting us brood on what life was for before we imposed our patterns on it. Meanings accumulate with subtle allusion to what is old, unrecognisable and free. Then a snag sets in. One of the stems has wound round in a complete triangle and re-entered the ground. At once we realise that every response for which the grove stands has been contradicted; not freedom purely, but compulsion, too. One self-assertive element has gone its own way, and ended in defeat. All our attempts to find a niche for the triangular shape end in doubt and constraint.

The mind struggles with these contradictions, searches elsewhere for resolution to the problem, and discovers a granular sheet creeping over the hillside, a white ashy layer with its own ragged character and qualities which do not extend down into the soil or match the trees, a kind of cleansing layer that has little to do with freedom, and little to do with the constraints that have followed the image. Likenesses now compete with each other, and compete without ever getting to grips in a way which would explain these resemblances and differences with their continually changing emphasis on strength, privacy and independence. Within the scene resemblances divagate and multiply. Multi-metaphoricity points to the condition of a poem: Stathatos gives us the photograph as poetry, and the mystery of the glen and the ongoing mystery of the photograph take on the mystery of poetry itself, for which there is also no definition, no beginning or end, and which continues to invent its suggestions as contacts within the poem relocate in moods and wonder and an enveloping expressiveness concerning the on-going past which has its counterpart in the unknown depth of our own nature.

Sarandos Diakopoulos: Self-portrait With Friends (c1920)

Sarandos Diakopoulos emigrated to Australia in 1908 to find a fortune, found it under the name Sydney James Diamonds, returned home to Greece in 1927, and died during the 50s. In Australia, nobody knows how or why, he developed into a photographer. One day he invited other three men to sit with him in the forest and be photographed. He understood the need to preserve what happened to him, but the other men were actors coerced or invited into their parts, and they became impatient and uneasy, playing their roles rebelliously against him and against the photograph, focusing him within the drama he was staging; a metaphor of his own life's adventure and isolation, and of the difference between him and them which made him what he was and defined him in his own over-brimming life.

The grandest, most theatrical backdrop was a lake extending for miles to hilly deserted shores, in front of which, standing up in an open rowing boat, he performed himself by waving his hat in a pointed gesture. At whom? Suspicion dawns that it was partly at us. That for the time being was the story and it was his story, but the time being became the time that was, and preserved,

Sarandos Diakopoulos, Self-portrait with Friends, *c1920; used in* Sydney James Diamonds in Australia, *1990*

impeccably in the amber of his photography, radiant with life, his life, his belief in himself and his own existence and his belief in the power of photography and its means to convey life – an inner conviction which matched the power of the medium but was his own deepest personality trait.

So the time was left behind without losing any of the fragrance, enigmatic charm and force of the man that was. A new elegiac radiance emerges from him and his one-time life, in which time passing reaches a climax and becomes perceptible, almost tangible as the time that was: all our times, if we could grasp them with the fierceness he did, and consummate them in a vision that would last forever.

This was Clifford Myerson's last essay; it was completed in hospital, very shortly before he succumbed to the illness which he had fought for many years.

jodhpurs and calf-length leather boots, an ensemble with a vague but unmistakable East European flavour. The five-pointed star clearly visible on certain belt buckles identifies the men as Warsaw Pact troops of some kind – a detail confirmed by our knowledge that the author of this work comes from Estonia, a country only recently released from a reluctant membership of the Union of Soviet Socialist Republics.

A work of appropriation, then, since Linnap, born in 1960, could hardly have been responsible for exposing the original negatives – clearly, also, a work of art which cries out for a strictly formalist reading; and yet, it is impossible to avoid the temptation to continue this apparently banal, almost reductive reading of the images.

What can we tell about the young soldiers who were the protagonists of this idyllic summer day nearly four decades ago? (We know it was a summer day because the title tells us so, and that it was an idyll because of the wonderfully fluffy clouds in an otherwise blue sky, and because the soldiers are engaged in nothing which a military mind would recognise as constructive). We also know that these are mere soldiers because on none of the uniforms are there any badges of rank – not an officer in sight, not even a corporal. They are not otherwise a particularly homogeneous group, ranging from a dashing young Elvis Presley look-alike to a studious fellow whose forehead, under his absurd cocked cap, can be seen to have gone prematurely bald.

What they are up to, in this presumably brief holiday from authority, is playing with guns, specifically medium-calibre automatic pistols; which means indulging in the quasi-universal adolescent male activity of posing with handguns, particularly as one

hedge; were it not for the fact that it is so perfectly positioned in the sky, one might legitimately doubt whether the photographer was even aware of the aircraft's presence in his viewfinder. In any case, there is such a quality of silence to this image that I feel the aircraft must have been a glider – the shape is certainly right. The distinction is important, for a landing aeroplane *powers* its way to the ground, while a glider *drifts* down, letting itself finally fall from the altitude of a single centimetre.

What is the purpose of such analysis? Has it told us anything further about *Summer 1955*? Oddly enough, yes. To be of any use to an artist, photographs must be rooted in a context, in a past; there is no such thing as a context-free photograph, and abstract photography is good for nothing but record covers. These images of Estonian university cadets undergoing military training in the Soviet armed forces were taken by Enn Kiiler, Peeter Linnap's father-in-law. Rediscovered by the artist and subjected to a process never dreamed off by their progenitor, a process extending not just to their enlargement but, most importantly, to their forcible co-option into an undreamed-of cultural and aesthetic context, they acquire an iconic status – which is merely to say that their meaning, and the readings they are subject to, has gone from the particular to the general, from the here-and-now to the timeless. They are no longer Kiiler's, nor even of course Linnap's: they have acquired an independent authority.

This strategy is hardly original, depending as it does on the nostalgia and pathos which all old photographs generate. The problem with *Summer 1995* is, as Jan-Erik-Lundström has perceptively noted, that 'these particular photos somehow refuse to settle', 'oscillating between seriousness and prankishness'. They

can perhaps be read as a comment on the Soviet occupation, but on the basis of these images alone, service in the armed forces of the occupier does not seem to have been particularly arduous. We can also find in them a paradigm of ritualised masculine behaviour, a parody of militarism, or a parable of Estonian resistance to the pretensions of their occupiers; they

can certainly support all of these readings.

There is, however, an additional dimension to this work which has to do with a certain disconcerting innocence present in the images – disconcerting, because innocence is not necessarily a quality one associates with representations of gun-wielding young men. It is present in the self-mockery evident in some of

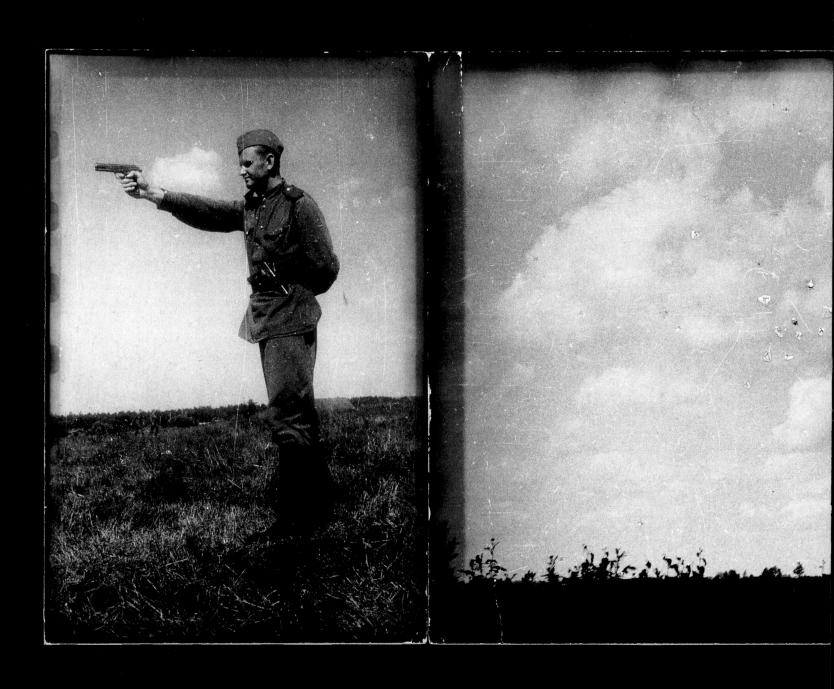

the poses, in the determinedly non-martial air of certain partici-pants (the photographer among them), in the same small, fluffy cloud which hangs just above the young men, in the stillness of the windless day, and – above all – in the silence of the stalled glider which is for me at the very centre of *Summer 1955*. If this work is about anything other than stillness and recollection, then it is about the infantile nature of power and of the means by which it seeks to perpetuate itself; and so it may after all, as staged by Linnap years after the event, also speak to us about resistance to power.

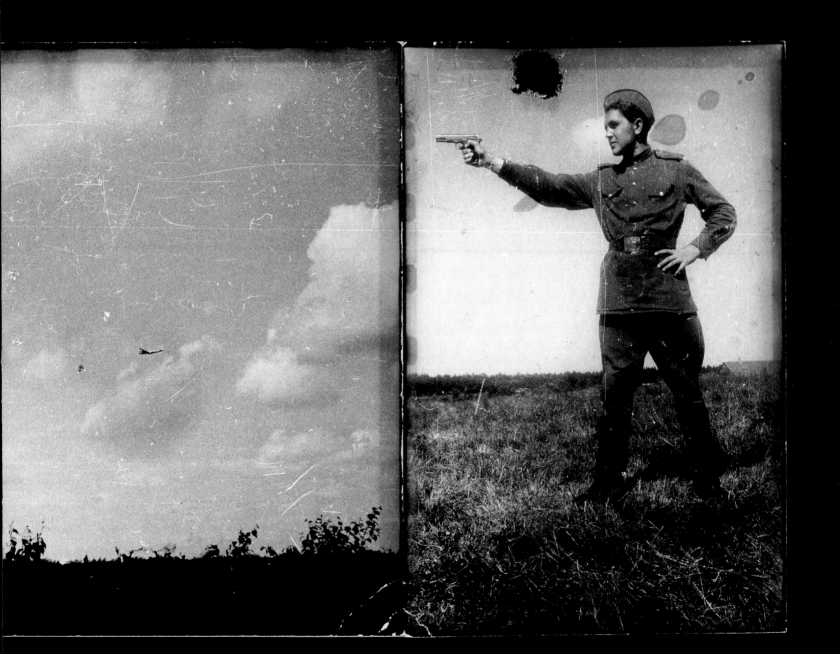

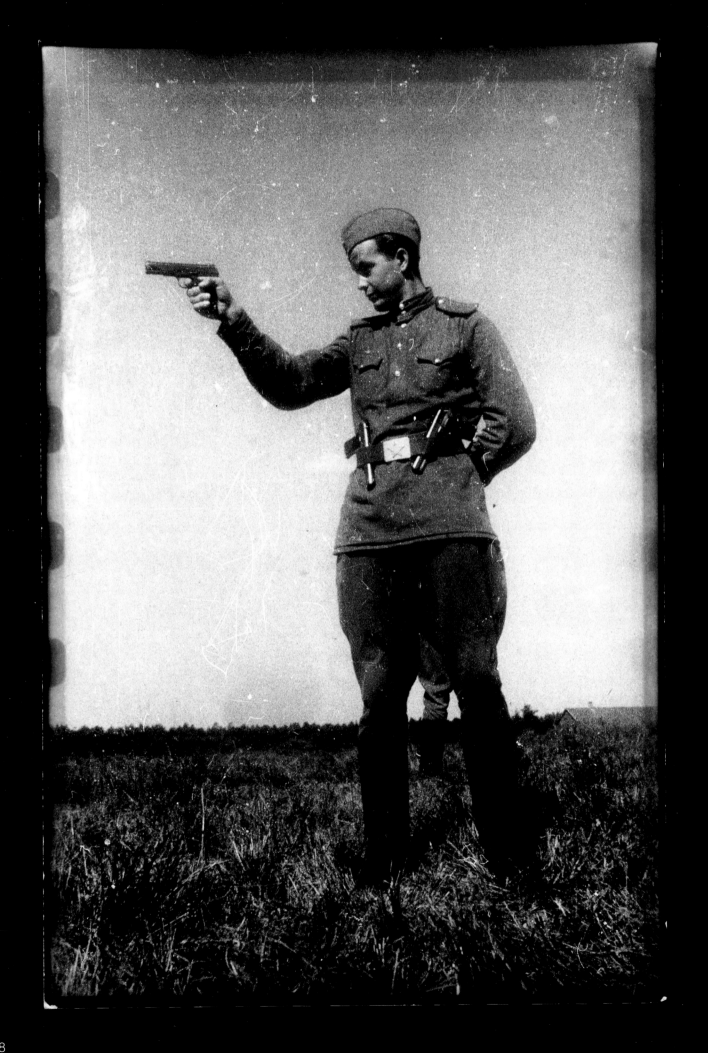

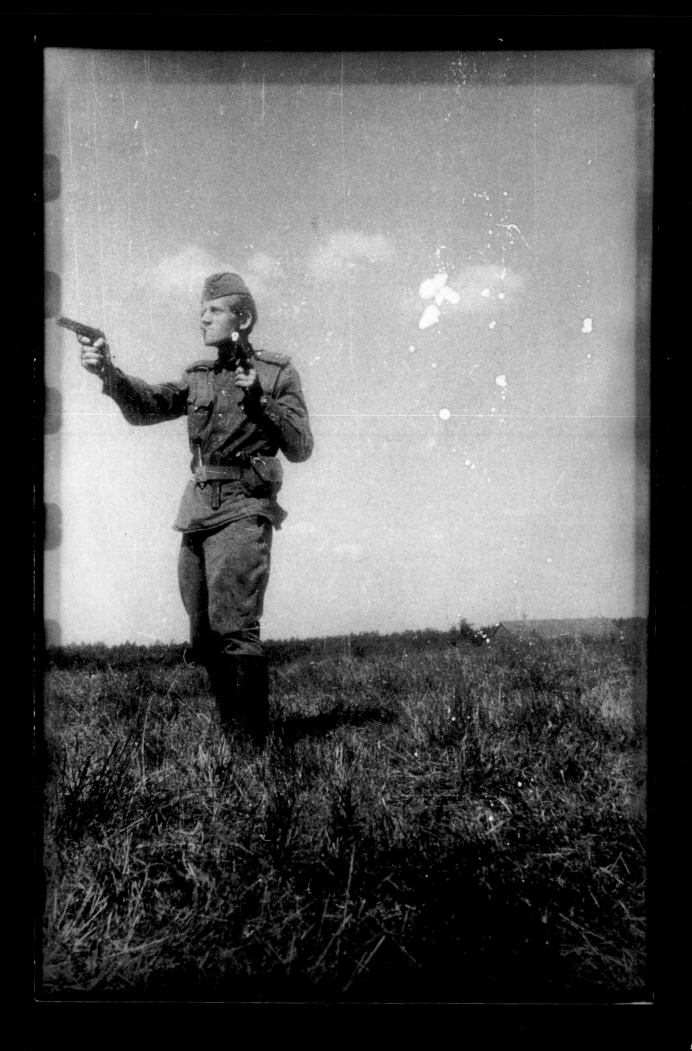

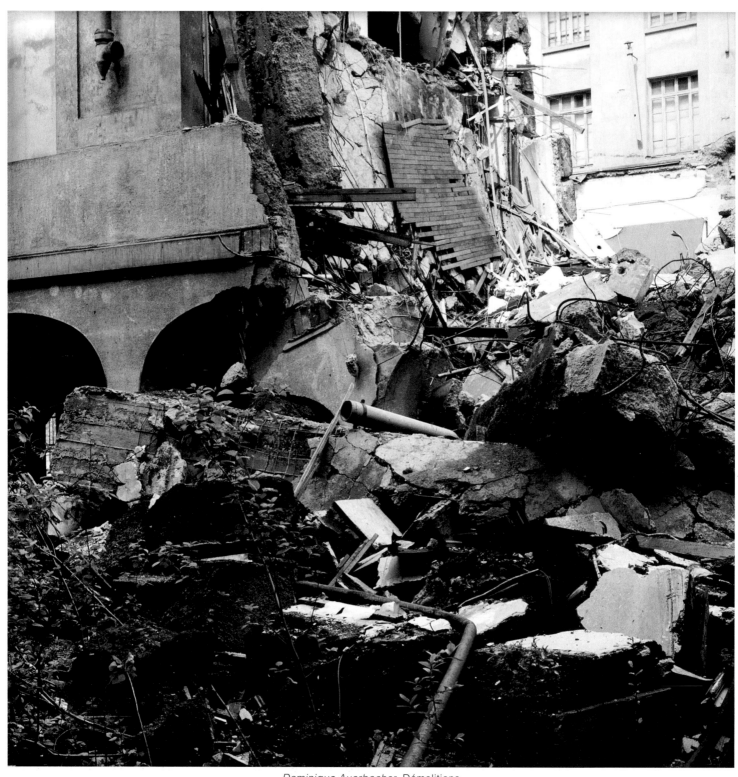

Dominique Auerbacher, Démolitions

THE (MIS)ADVENTURES OF PHOTOGRAPHIC MEMORY
RECENT EPISODES FROM AN ONGOING TALE
YVES ABRIOUX

Metaphysics

Fifteen years after the death of Roland Barthes and the publication of *Camera Lucida*, the notion that photographic knowledge is intimately bound up with the passage of time and the anticipation of death continues to holds sway.

It would be wrong, of course, to reduce Barthes' obsession with photography and the past to a question of nostalgia. Firstly, because the acuteness of his anguish at his mother's death makes itself felt throughout *Camera Lucida*, but also because Barthes states that the mere physical presence of a photograph stirs in him an altogether more dignified name: that of metaphysics. A simple or 'stupid' kind of metaphysics, he agrees, but that which is probably 'true metaphysics'. The expression gives the game away. If the discourse of photography remains obsessed by questions of time, origin and genuineness, it is because Western culture remains largely under the cruelly watchful eye of its Platonic superego. This is true whether, like Barthes, commentators argue for the metaphysical dignity of photography or whether, like Susan Sontag, they begin their critique of our century's surfeit of photographic imagery 'in Plato's cave'.[1] More than a century after Nietzsche's call for militant forgetfulness, much writing on photography continues to be imbued with a vague sense of Platonic memory-patterns. Surely photography is capable of other missions than those assigned to it in this tradition.[2]

Too late?

It should be acknowledged that the current cultural and technical situation of photography does not hold out much obvious promise. Indeed, the work of a photographer like Lewis Baltz suggests that the end of a certain road has been reached.

The anonymous modern architecture which occupies Baltz's photographs from the 70s (*Tract Houses*, *The New Industrial Parks Near Irvine, California*, etc) speaks of a blankness from which any notion of memory can only have been erased, while his photographs from the 80s (*San Quentin Point*, *Fos Secteur 80*, etc) – close-ups of debris accumulating in the margins of such developments – show what progress of this kind is doing to the environment. The 'dialectic of nature and culture' is producing entropy: 'Endsites; *endezeit*'.[3]

It is not just this evolution which induces grimness. While Baltz was coldly putting on record a process of degradation, the increasing sophistication of image technology was being turned to the task of policing the planet. The artist's 'high technology' series of the 90s takes stock of the latter situation. If an installation like *Ronde de Nuit* again uses mostly close-ups, this time they are large colour panels which create a fragmented but all-invading nightmare world, in which the mechanised image is identified with observation and control.

Remembering

The cold brutality of high-technology surveillance emphasises the extent to which Barthes, giving metaphysical dignity to the process of sorting through family photographs, now appears as a character from a old-fashioned book. The production of figures of memory in our era of accelerating standardised electronic imagery increasingly requires rhetorical finesse, as in Corinne Mercadier's Polaroid enlargements, characteristically situated between water and land.

These works are untitled, their location some unspecified backwater. They do not, however, show the margins of 'progress', but rather the fringes of an unidentified subject's biography. Mercadier's photographs are almost like memories of holiday snaps; they are the after-image of distant days, which emerge not so much as landmarks but as indistinct forms, or perhaps a particular quality of colour. These features alone locally transcend the overall framework of sepia tones and water's-edge details, redolent of an earlier age of photography. It is as if, from the workings of a memory almost erased by the blank wash of water and sky, all that could be saved were a few such patches of visual intensity. Confronted by the peculiar technical qualities of Mercadier's work, the viewer may well ponder on the internal – ie psychic and perceptive – mechanism(s) susceptible of creating a meaningful memory somewhere between forgetfulness and the invasive clichés of our sharply focused, increasingly visually-controlled world.

Contra Tempo

Contemporary photography follows diverse paths in an effort to create resonant pockets of time. When I had a print made from the slide Seton Smith lent me of *Caps & Bed* – an uncanny diptych I had seen twice previously – it came back from the laboratory with a 'quality control' note regretfully stating that everything had been done to try to provide me with a satisfactory product . . . I then had to leave the photograph around for some time for its compelling quality to re-emerge from the haziness (accentuated by the play of reflections caught in the left-hand-side panel) and provide reassurance that my memory had not been playing tricks on me.

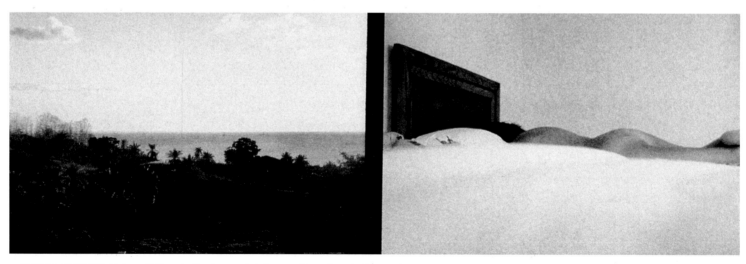

ABOVE, CENTRE: Holger Trülzsch, Sculpture éphémère: Domaine de Kerguehennec, *1986; BELOW: Denis Roche,* 4 avril 1989, Trinidad, Farrell House, chambre 3202

Sometimes deliberately hazy or apparently badly centred, Seton Smith's photographs chiefly show subjects that might almost be extracted from a tourist's photograph album – landscapes or individual trees, rooms, corridors, stairwells and details from what look like stately homes. However, these works are not fundamentally a pastiche of cultural tourism, such as would engender a critique of a particular form of stereotyped vision.

The details in Seton Smith's photographs – bonnets, reflected figures, oval portraits, chandeliers, drapes; but also architectural or natural features such as balustrades, doorways, islands, trees – vibrate before the viewer's eyes, acquiring the quality of what Deleuze and Guattari define as 'blocks of percepts and affects'[4] – that is, pure sensation unfocused by human passions, whose residual influence on our gaze is what gives some of these photographs an air of awkwardness. Seton Smith's apparently arbitrary diptychs function contrapuntally to allow affects and percepts to emerge and attain the degree of consistency necessary for their survival. They reformulate the notion of monument, so that this no longer refers to the allure of the architectural or natural sites whose residual presence hovers in the background as we contemplate her work, but must rather be understood as what allows 'the compound of created sensations [to be] conserved in itself'. In a peculiar temporal suspension, their creative forgetfulness of visual norms acts also against the grain of time, reawakening the euphoria of a state of being which these norms characteristically squeeze out of our sensibilities.

Forgetting

The salutary forgetfulness of the camera eye may take on an altogether more spectacular form. In work produced by Robert Doisneau in the early 80s it almost constitutes an explicit motif. Seventy years old and with an illustrious career behind him, Doisneau successfully combated the burden of a spurious tradition by producing an astonishing series of colour photographs of recently-constructed Paris suburbs In these the facile humanist aesthetic of the black-and-white studies by the photographer of Paris and its surroundings during the post-war years seems to have been banished from his memory. His studies were now coldly focused and framed, with a formal rigour that underscores the inhumanity of many a contemporary dormitory town. Something had obviously occurred to set the photographer off-balance.

Missions

Surprisingly, perhaps, the impulse for Doisneau's salutary forgetfulness came from a public commission. Like Baltz's *Fos Secteur 80*, his later photographs of Paris suburbs were produced in the context of a 'photographic mission' – a major survey of the French landscape sponsored in the early 80s by the DATAR, a branch of the Ministry of the Environment. Baltz's 'high technology' *Ronde de Nuit* belongs to another such project (as yet uncompleted), centred on the construction of the Channel Tunnel and conducted by the Mission Photographique Transmanche. Far from seeking to impose one particular approach, those responsible for both of these projects have declared their interest in conducting a simultaneous survey of the state of photography and the state of the landscape. Furthermore, the 'missions' have stimulated public discussion and documentation of administrative, technical and other practical considerations.[5]

As Lewis Baltz's two contributions demonstrate, the problem is not only that the state of the late-industrial world is so destructive of the landscapes that photographers are being asked to record, but also that the mechanised image readily becomes the accomplice of institutionalised control. How, to illustrate a different aspect of the latter problem, is one to reconcile a minister's concern that the work conducted under his aegis should produce an 'exact reflection' of contemporary France, with the same minister's willingness to entrust its realisation to the 'personal vision' of talented photographers? The mission entrusted to photographers in such a context is clearly not incontrovertible. Memory is not merely a question of the resonance of images. Whether in Roland Barthes' photo album or a publicly sponsored publication, it has a larger political and/or historical dimension.

Authenticity

How, for example, is one to judge the relevance of a photograph? A minor controversy was stirred by the inclusion of photographs taken in Hungary or Italy in the work conducted by Dominique Auerbacher for the DATAR – a gesture which, while evidently at odds with the 'documentary' ambition of the mission she was serving, was wholly coherent in terms of the problematics of subjective vision. Interestingly, the Mission Transmanche has adopted a more generous approach, declaring that a photographic domain [*champ*] need not necessarily be defined as a territory [*territoire*] and willingly accepting original work based on photographic material geographically and/or historically remote from northern France.[6] This is perhaps one way in which memory can become part of the photographer's active domain and not a simple expression of his or her taskmaster's ambitions for posterity.

Archive

Pierre Devin of the Mission Transmanche sums up the complexity of institutionalised memory by declaring that his ambition is not to produce a photographic archive but an artistic heritage [*patrimoine artistique*]. Attractive though this proposition may be, however, it perhaps underestimates the inherently archival nature of photography.[7]

The notion of the archive is a complex one. Dealing as it does with matters of documentation and storage, it implies at once a material origin – which is to say an origin physical, historical, ontological . . . – and an authority which consigns and preserves.[8] An archive also has the 'supplementary' status of a supposedly external aid to memory. Interestingly, the structure of

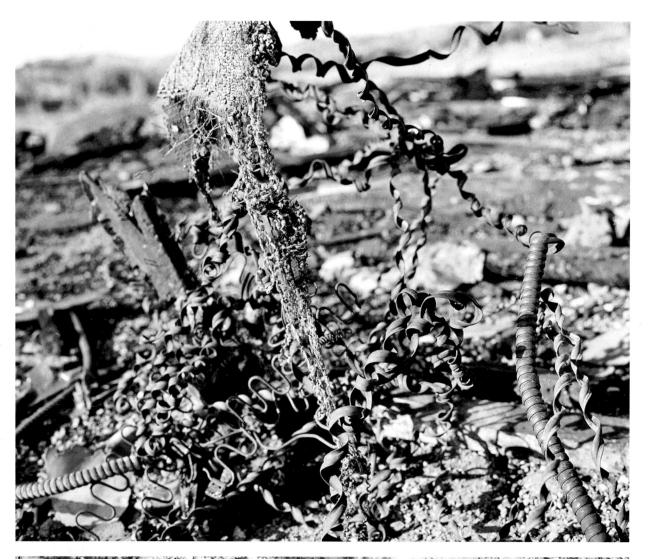

Lewis Baltz, FROM ABOVE: San Quentin Point, *1985-86, element No 42 from a series of 58 photographs;* Fos Secteur 80, *1986, element No 15 from a series of 21 photographs*

photography is itself inherently supplementary, in something like the sense this term has acquired from Derrida.[9] It has become commonplace to insist on the fact that a photograph is an index – a sign causally related to its referent. However, this fact is not in any obvious way inscribed on the surface of the print. Indeed, in so far as one might have a 'naive' impression of a photograph, this would indicate it to be iconic – ie, analogically related to its referent. The fact it is *also* an index is actually provided by our knowledge of the way the image has been produced. In other words, the indexical status of the photograph pertains to our – constructed – sense of what a photograph is.[10] It is supplementary without, however, being secondary.

Memories

Once photography had been invented, it rapidly required an institutional force such that painting was impelled to respond to its representational (ie iconic) powers. It was not long before the representational authority of photography was evoked to explain, say, painterly abstraction or certain manifestations of avant-garde agitation. More recently (as in some Pop Art, hyperrealism, etc) photography has compelled painting to face up to the fact that certain iconic codes now tend conventionally to be read as indexical, whatever the means of production of the image in which they may be found – an evolution which, situating photography as it were in painting's memory, reverses the presuppositions of the pictorialist schools of photography and demonstrates how authority may paradoxically pre-empt chronology. In the work of some contemporary artists, for whom photography is one medium amongst others, the inherently multiple nature of the photographic sign forces the interplay with other visual arts in yet other directions.

Sculpture

It is tempting to read the inherently supplementary structure of photographs in binary – and potentially dialectical – terms by opposing the primarily temporal aspect of their indexical status to the presumably spatial nature of their iconic dimension.[11] However, the resonance of the photographic image implies an altogether more complex temporal structure.

The monumental polyptychs which Pascal Kern has entitled *Sculpture* consist of life-sized photographs of disused moulds – monuments of a now more or less defunct stage of industrial production. However, the mark of time past does not primarily emerge from the indexical sign constituted by the well-worn aspect of the moulds. Indeed, the effects of ageing thus manifested are largely sublimated by the fully frontal angle of vision which allows the chromatic qualities of the objects to emerge in their own right as an aesthetic effect. The first lesson of Kern's works – which have all the appearance of museum pieces – is that they confirm that an artistic context will tend pragmatically to redefine the status of photographs.

Paradoxically, it is not the indexical dimension of the photo-graph which most powerfully suggests a concern with memory, but rather the overall appearance of the 'sculptures' – their heavy, man-made quality (underlined by the wooden frames), which insistently evokes an earlier artistic moment than the smoothly technological photographic images with which they critically – or perhaps defensively – interact. The serial nature of the works further underlines the extent to which memory here is a question of artistic conventions, implying as it does a sort of fictional catalogue of forms, materials and colours.

Ephemera

While the interweaving of technologies in Kern's 'sculptures' leaves one with the suspicion that they may testify to an anachronistic effort on the part of artistic tradition to assert its control over the supplementary potential which photography embarrassingly affords it, another aspect of the history of these adds further twist to the tale. A few years ago, Kern's studio tragically burned down, destroying not only the moulds but also his 'sculptures'. Almost all that remains today are documentary photographs such as the one reproduced here.[12] Do these preserve the memory of the sculptures, or rather the memory of the moulds? A question such as this is not merely anecdotal but also says something about the nature of photography. It has implications that can perhaps best be illustrated by the institutional, rather than accidental, mishap that has befallen another series of photographs intimately bound up with sculpture and memory.

In the mid-80s, Holger Trülzsch was one of the first artists to be invited to work in the 'sculpture park' then opening at Kerguehennec in Brittany. Apart from Trülzsch's own notes and sketches, all that remains of his intervention is a series of photographs, repeated at varying times of the day or year. These show thickets in which a particular arrangement of trunks or branches imposes its presence. The repetition is instrumental to the emergence of the notional 'sculptures' produced by the artist. Indeed, although the site of the 'works' – so far as they ever materially existed – was originally marked by standing stones, they have long since returned to nature.

The memory function of these photographs is essentially twofold. In the constitutive moment of the artist's action, they endow neglected spaces with a sense of *déjà vu* – drawing (for instance) on our formal memories of modernist abstraction to create an syncretic *genius loci*. Woodland can never simply be a site in which to deposit yet one more object (as it is for much of the 'real' sculpture to be seen at Kerguehennec); it is something that has always already been looked at. In the aftermath of Trülzsch's intervention, the photographs remain as concretions testifying to the persistence of that gaze; they are not objects of the gaze but the gaze as object. It is perhaps not surprising that the sculpture park's administrators killed off this paradoxical object captured by the camera, simply by ridding themselves of the memory of the entire project, failing even to mention it in a recent volume retracing Kerguehennec's early years. When I last

visited the park, I was told that Trülzsch's project had been ephemeral – a statement implicitly relegating the photographs, which remain in the artist's possession, to the condition of a mere record in a linear time-flow.

Fragments

Exploring the kind of setting in which contemporary sculpture has far from advantageously replaced picturesque ruins, Trülzsch casts a new light on Susan Sontag's dismissal of photographs as 'artificial ruins'. Sontag decries the way photography as an elegiac art nourishes a passive attitude to reality by stimulating sentimental aesthetic consumerism, and further bemoans the manner in which photographs become all the more readily assimilated to the spurious 'instant romanticism' which this aspect of their temporal structure stimulates, by themselves acquiring age-value. However, the erasure of Trülzsch's work from the memory of Kerguehennec perversely acts as an homage to the way his photographs implicitly contest what is after all no more than an admittedly powerful convention built upon the indexical status of the photographic image.[13] It nevertheless remains that photographic records of changing landscapes – especially when, as so often (at least in France) they are institutionally sponsored – constitute one of the sternest tests of photography's powers of creative resistance.

In 1991, Dominique Auerbacher first exhibited an installation consisting chiefly of 25 photographs of a demolition site.[14] Some of the views included in this are clearly descriptive. However, the foreground rubble transforms these into pre-romantic ruins, so that (for example) a facade partially covered by vertically hanging debris takes on the appearance of a classical temple, while a semi-demolished arcade resembles the ruins of a monumental bridge. Alongside these more representational photographs, Auerbacher's frontal close-ups of the textural effects of rubble are abstract.

Curiously, in a gesture which might almost confirm Sontag's critique of photography as encouraging acquisitive relations to the world, Auerbacher's installation, with its framed photographs hung at all levels on the walls, would at first sight have seemed to echo a collector's picture gallery, had it not been for the blank spaces between photos, which emphasised the fragmentation these depict. The installation also included three monumental but obscured views, through a doorway, of the naked body of an ageing woman. Cut off at the shoulders and above the knees, these photographs reverse the effect of the demolition photographs by endowing with monumental status, simply by truncating it, something which would be regarded as a wreck.

Far from being casually tinged with the melancholy of ageing

and obsolescence, the effect of the installation was to accentuate a rhythm at once destructive and paradoxically creative in its harshness. As the artist states, demolition, body and the gaze are all put on the same level. Whether, responding to the paradoxes of fragmentation, the viewer prolongs the rhythm which induces this effect or (as Sontag implies all viewers of photography will do) hoards the fallen pieces that can be fantasised over as a defence shored up against desolation, ultimately depends on his or her capacity to measure up to the fixed stare of the multiple focal lengths of the camera's mechanical eye.[15]

Chimera

Where Auerbach's photographic installation mobilises a rhythmic capacity and an image of embodiment doubtless contained in each of our memories, Denis Roche's preservation of contact prints in precisely the sequence in which they were taken exploits the way in which a roll of film mechanically functions as a memory bank. It is this involuntary printed memory which integrates the photographer's shadow and the slope of an adjacent landscape into a composite block in which accidental formal coherence captures representational imagery in its web. The originality of an accidental compound such as this becomes obvious when it is contrasted with the more overtly hermeneutic formalist accident in which the same accidental printed memory slips dangerously close to sentimentality by assimilating a naked body on a bed to a landscape.[16]

If, in the latter case, the camera's mechanical memory functions as a straightforward supplement to the imagination, which it stimulates without challenging the norms of formal perception, the lesson to be drawn from the other, more enigmatic landscape/self-portrait can perhaps be more clearly read in a third set of juxtaposed contact prints. Here the pattern of lines running on from one photograph to the next composes a compound being, both human and mechanical, which itself is drawn into a simultaneously representational and abstract compound. Insofar as the fear of uncontrollable simulacra pushed Plato to severely restrict the legitimacy of images, the chimera (in Greek mythology, a monster made up of parts of different beasts) which emerges here from a play of shadows would doubtless have given him nightmares. However, whatever the uses to which image technology will find itself increasingly be put in an age in which it forms an integral part of social and political control, it is precisely this open combination of the photographic operator and his or her mechanical supplement that, allows us to hope that the continued invention of other, non-normative uses of photography will prove to be something other than chimerical (in the vulgar sense).

Notes

1 This is, of course the title of the first chapter of *On Photography* (1977). Also significant is the fact that Barthes concluded the notes he wrote to accompany a portfolio of photographs by Daniel Boudinet by describing these as 'a sort of silent invitation to... "philosophise" ' (*Creatis* No 4, 1977). The frontispiece of *Camera Lucida* – and the only colour photograph in the volume – is also by Boudinet, although Barthes makes no reference to the artist in his text. At the very beginning of the book, he states that it is the contingency with which photographs are weighted that makes them resist being absorbed into philosophical discourse, suggesting that 'metaphysics' is the name the book gives to the extra turn of the screw which this tragic contingency gives to mere 'philosophy'.

2 Nor should it be forgotten that Barthes himself suggested that he might prove to have been one of the last witnesses of the 'metaphysical' shock provoked by the peculiar internal chronology of the photograph.

3 The quotations are from notes written by Lewis Baltz on the occasion of an exhibition at the Michèle Chomette Gallery, Paris, 1988.

4 *Qu'est-ce que la Philosophie?* (1991)

5 For the first of these projects, see the two volumes, both entitled *Paysages Photographies*, published by the DATAR in 1985 and 1989. Detailed technical and administrative information is contained in the earlier publication. The Mission Photographique Transmanche will soon have published twenty volumes, with perhaps another ten to follow. Its principles and working methods were clearly set out by its director, Pierre Devin, at a symposium organised by the Folkwang Museum, Essen in December 1993. The confrontation of photographic practice and a major event such as the construction of the Channel Tunnel has unfortunately produced scarcely more than embrionic results, devoid of any coherent purpose, in the Mission's English counterpart, the Kent-based Cross Channel Photographic Mission.

6 Such as Tim Brennan's work on *Fortress Europe* or Wojciech Prazmowski's *L'Ange Brisée*.

7 Pragmatically it engenders a generous attitude, leading for example to the Mission Transmanche's insistence on developing an open collaborative relationship with photographers (cf note 2 above).

8 The concepts of *heritage* and *patrimoine* are functions of the more general economy of the archive, and furthermore suggest that this is not free of considerations of sexual politics – an issue to which Dominique Auerbacher's 'false' documentation in the DATAR mission also bears witness. It is neither irrelevant – nor, I believe, accidental – that this minor perversion of archival authority should have been the work of a woman artist.

9 For a sophisticated discussion of the archive and the logic of heritage, see Derrida's recently published *Mal d'Archive* (1995).

10 J-M Schaeffer ('Du Beau au sublime?', *Critique* No 459-60, 1985) suggests the definition of the photographic image as indexical is pragmatic: 'the constitution of the [photographic] image as an index results from collateral knowledge which supplies me with the communicational norms via which I am supposed to approach it'. It remains to be seen whether this norm is necessarily predominant in our approach to photography. The semiological distinctions between symbol, icon and index were, of course, established by C S Pierce in the late 19th century. Pierce himself pointed out the dual aspect of photographs, but in a spirit more concerned with distinguishing between painting and photography as classes of signs (icon and index).

11 The latter induces a description of photographs in terms of visual effects and/or technical characteristics (centring, contrast, etc).

12 In fact, Kern also used one of the moulds as a block to execute a series of prints. By a cruel twist of irony, these projected multiples have now inherited the status of originals. The artist no longer even possess an adequate reproduction of the photographic dyptich of this mould.

13 As opposed to the loss of Kern's sculptures, which before their disappearance already engendered a certain pathos.

14 A second exhibition, organised like the first by the Centre Régional de la Photographie Nord Pas-de-Calais (which also houses the Mission Photographique Transmanche), adopted a different format from the one described here.

15 And to the additional rhythmic potential obtained by the manipulation of photographic prints. Auerbacher's monumental nudes were coloured with pastels before being enlarged in a photocopying machine. This process produced 16 fragments – displaying disseminated effects of colouring and grain – which were then visibly stuck together.

16 Recalling Susan's Sontag's justly sardonic observation that 'Instructed by photographs, everyone is able to visualise that once purely literary conceit, the geography of the body: for example, photographing a pregnant woman so that her body looks like a hillock, a hillock so that it looks like the body of a pregnant woman'.

FROM ABOVE, L TO R: Pascal Kern, Sculpture, *1992, diptyque, 64 x 146cm; Seton Smith,* Caps and Bed, *1990, cibachrome, Plexiglas, 180 x 120cm; Corinne Mercadier,* Sans titre No.4, *1992, polaroid, 49.6 x 48.6cm; Corinne Mercadier,* Sans titre No.2, *1992, polaroid, 49.6 x 48.5cm*

III

THE CONSTRUCTED IMAGE

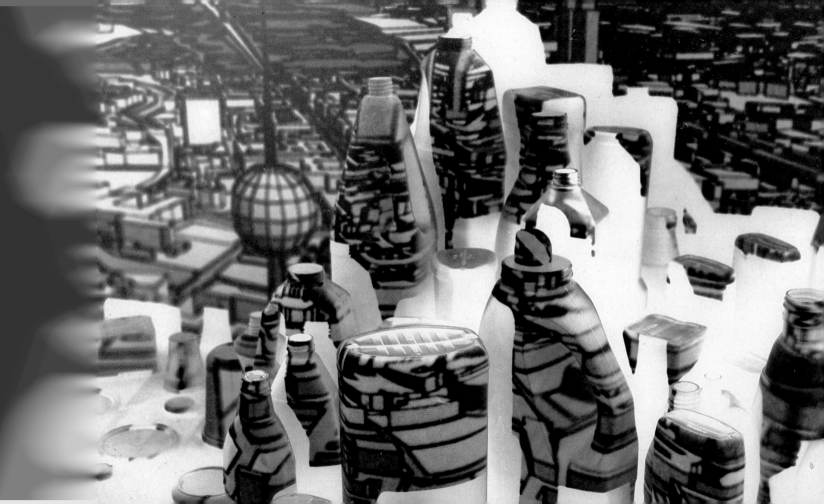

VISIBLE CITIES
GRAHAM BUDGETT
GRAHAM EVANS

Graham Budgett's *Berlin By Night* series developed an innovatory montage technique of multiple in-camera exposures to make some sharp political and cultural statements about Berlin in the 1980s. These production techniques have been refined and extended in *Visible Cities*, a new body of work, part of which was first shown in the exhibition *Zeit-Mauer* (Time-Wall) at London's Goethe Institute in spring 1992 and subsequently toured in Germany. *Zeit-Mauer*, which was constructed around responses to the reunification of Germany and the fall of the Berlin Wall, included the work of West Berlin painter Toni Wirthmuller and East Berlin installation artist Rainer Gorss. Since then, Budgett has added to this series of constructed images of imaginary cityscapes which offer a simultaneous view across the imaginary cities of both the past and the future.

This strange combination of futuristic and historical, solid and ethereal, has been achieved by projecting transparencies of real, if fragmentary, urban scenes, mostly of Berlin, onto tabletop urban landscapes made up of empty detergent and liquid soap containers – the detritus of everyday household goods. The resonance and meaning of this work becomes critical with Budgett's use of negative images projected onto his tableaux, copied onto positive film, printed as if from a negative and finally toned to a cold blue shade; the final images, greatly enlarged,

are hung unframed, tensioned and faintly curved between steel fixing rods placed at each corner.

While these images may perhaps allude to the cleansing of a troubled past, his cacophony of urban landscape uses the iconography of the past combined with the grotesquely multiplied refuse of capitalism to speak of the dystopia of late-20th-century cities, deconstructing the very notion of the portrayal of place. The point is made, insistently, that the very notion of city is obscure and its current definitions in flux.

Each 'cityscape' is identified by the name of a mythical city, the names themselves – *Penthesilea, Laudomia, Eudoxia, Diomira* – resonant of classical, or perhaps mythical allusions. In fact, the alert viewer will recognise them as the names invented, or rather adapted, by Italo Calvino for the imaginary cities in his novel *Invisible Cities*. Calvino's Marco Polo, called upon by Kublai Khan to describe the cities of his empire, ends up describing the same city over and over again. Conceding the impossibility of description (of representation), Marco Polo can only take refuge in the re-presentation of the one city he can claim to know well enough to describe – his own home city of Venice. For Budgett, one of the subtexts running through *Visible Cities* is that of the inescapable subjectivity of the reporter.

Visible Cities, *1992, installation, Goethe Institute, London*

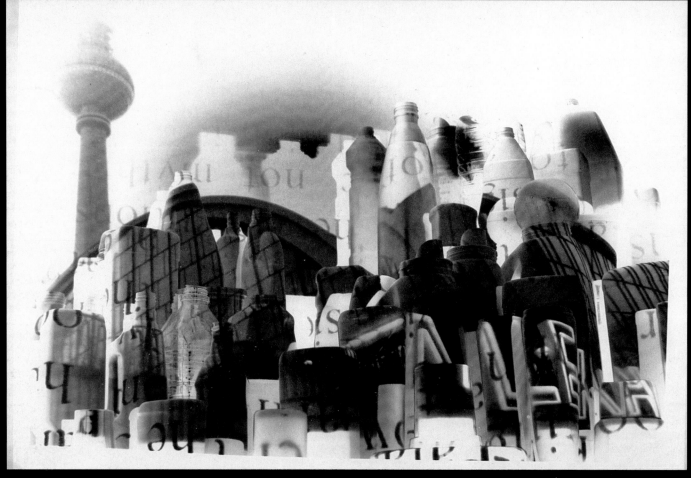

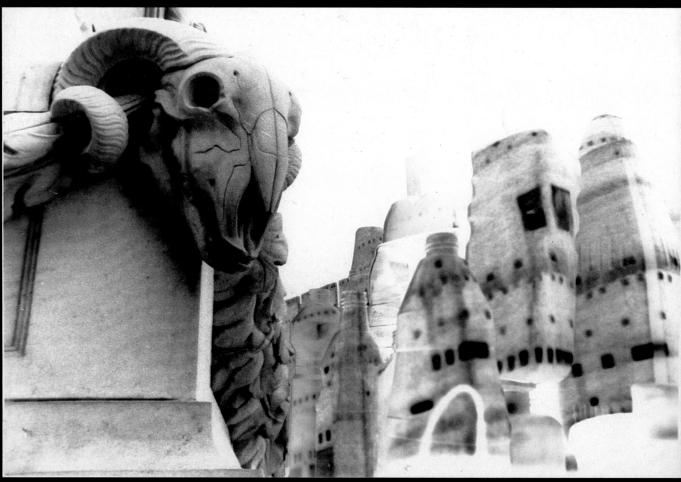

FROM ABOVE: Isadora, *toned silver print, 106.7 x 152.4cm;* Eusopia, *toned silver print, 106.7 x 152.4cm*

FROM ABOVE: Graham Budgett, (Zoo)Logical Garden *from* Berlin by Night, *1987, cibachrome print; Calum Colvin,* The Mute Swan, *1993, colour print*

AN ART OF CONSCIOUSNESS

Ian Jeffrey

Constructor-photographers dispense with the ontological guarantee which sustains classic photography. If the event takes place in its own time and space it can be relied upon as belonging to a larger order or to a reality which is, by definition, trustworthy. Interfere with the natural, pre-existent order and you enter the world of make-believe, where authority depends on strength of fantasy and imagination. Any real photograph makes demands, quite apart from the claims of authorship, because it is rich in the traces of the premeditated. Constructors dispense with such givens.

Historians assume a more or less continuous history of naturalism, increasingly challenged by the photography of intervention until the old order has been completely dissolved. That history, even if mainly an assumption, is wrong. Reportage photography of the Family of Man/Magnum kind was only firmly established in the 1930s and scarcely survived the 50s. The preferred aesthetic of the liberal democracies, it was their way of laying claim to the natural, and beyond that to the truthful. The photography of invention flourished in the 20s and in the pre-totalitarian era; you find it for instance in Berlin picture-making by such agencies as Fotoaktuel, which specialised in staged events and narratives. Totalitarianism, post-1933, raised the stakes, defining the photography of invention as inconsequential caprice, risible in terms of new fundamentalist values. By this token the restoration of the photography of invention represents something like a return to Weimar libertarianism.

How does constructionism function? Art's arena in the 80s and 90s is less the macro-political world that the art enclave itself, expressed in terms of festival shows: Documentas, Biennales, heavily curated ensembles in Paris. The unit of account is less the particular piece than the variegated mass to which the artist contributes largely in terms of difference. Two kinds of difference: in relation to what preceded, and in relation to other contemporary products. Festival itself presents plethora, and such novelty without end as would carry its audience away from a demanding ambience of assessment and judgement. Pure photography is inimical to this kind of event, because of the very strict demands it makes on attention. Documentary and other kinds of pure photography raise the possibility of non-hieratic time, of an order in which everything might matter if sufficiently closely scrutinised. Such a congested and mysterious time is incompatible with the ecstatic engrossments of Festival. Hence the relatively large scale of the constructors' work – near to life size in the case of Jeff Wall, Cindy Sherman, Calum Colvin and

Ron O'Donnell. The meaning of 'big' in such pieces is that encounter replaces scrutiny. Traditional or pure pictures were miniaturised extracts from the real world which, by virtue of miniaturisation, functioned as evidence from which readings could be taken. After an encounter, etiquette assumes that you move on, and in the context of Festival moving on is of the essence.

Likewise, Festival values invention, for it equals delight. Canonical documentary and reportage represent the status quo as seen, and beyond that they can function as metaphor. But metaphor is notoriously dubious as to meaning. If the photographer speaks a different language and has the life experience of another culture the meaning of the picture might be forever opaque, and therefore troubling. What is going on? What secrets stand to be revealed? Secrets, though, are the stuff of which analyses are made, and Festival requires brighter returns, independent of any personal predicament. The great virtue of constructionism is that it precludes the depth model; for a made art is an art of consciousness, deliberated.

Even a deliberated model, in the context of Festival, can have drawbacks, however, for it might carry with it elaborated, hermetic meanings. Constructed photography undoes these meanings, less for the sake of cultural nihilism than to keep them in being. If Calum Colvin repeats Tintoretto in his studio by photographing an assemblage of found objects, he is applying the *epokhè*, holding back and acknowledging the huge cultural apparatus underlying the art of that time. If Ron O'Donnell elaborates a scene which he calls *Osiris*, it amounts to a circumvention of the kind of genealogies which make impossible demands on the memory. Constructionist art looks like fairground vernacular, like Disneyland, Bayreuth or *Don Giovanni* staged by English National Opera. It looks fictive, and part-way to performance, and the reason has less to do with belittling the past than ridding it of whatever is onerous, encyclopaedic. Masquerade, creakingly got up in whatever colours, draws out all those historical encumbrances which blight the present.

Barbara Kruger, for instance, one of the most copious constructor-inventors of the last decade, makes constant use of black, white, red and sans-serif, the colours and styles of concern *c*1930-1950, but so topicalised – via inserted phrases specific to the 80s and 90s – as to redeem them from the archive and keep alive an original authority. Graham Budgett's preoccupations, likewise, are with sites historically invested or heavy with history, and they too are redeemed with invention, which means that his Berlin, for example, is re-established as a stage set. In

front of the real Berlin you are obliged to think of the real history of the city; a fabrication obliterates that obligation at a stroke, just as the actual voice of Don Giovanni preempts enquires about the meaning of the role and its evolution over the centuries.

Constructors deal in spectacle, and spectacle acts in the present moment, screening out history and memory. They are successors to, for example, the *pompiers* of the late 19th century who represented a classical past in terms of a savoury present, as instantly apprehensible. The *pompiers* were eventually held in contempt because of their denial of mind, but they were at work in a period when one mode ousted the other. In the constructors' era, by contrast, modes press hard on each other to the point of symbiosis, and the near-past extends into the present. Thus the constructors' luxuriant style co-exists with and complements a number of cathartic alternatives.

The shared concern, in every case, is with the copiousness of history, culture and collective memory, and with the inordinate complexity of what has been inherited, which now promises to stifle existence. Demonstrate that the past is chimerical, and you rid yourself of much of its burden. Hence historical problematisation in Foucault in which the longer reaches of the past were read in relation to, and subordinated to, present preoccupations. The past, under such terms, need not be treated with strict reference to its own ethos, but as a source. One of Jeff Wall's recent epics, *Restoration*, which describes a panoramic battle-piece under restoration in a Swiss museum, amounts to problemisation in action, for the represented event is re-represented in the photographic actuality of restoration. In this series of elisions it is the present which dominates, as history fades towards some putative origin in the Napoleonic era.

Wall's argument is with origins throughout. In another piece, *The Well*, a woman is engaged in digging a very serious-looking excavation, but through a variety of signs Wall betrays that this work is not seriously intended, that it is the staging and not the search that really matters. The same applies to his well-known staging of a street brawl which, while ostensibly evidential, immediately ceases to act as evidence once its contrivances show through. Straight photography, by contrast, was always posited on the sanctity of origins. Once the question of origins is raised there can be no relaxation, for they are by their nature unknowable. Wall and the constructors reply that although these may matter, they lie beyond possibility of excavation and might as well be left in peace.

Origins may be impossible to determine, but as absolutes they fascinate – and seem to be the subject of constructed photography. At one point, in 1987, Graham Budgett stages an *Expulsion from Paradise* at the neon-lit entry to Berlin's Zoologischer Garten in a doubled reflection on origins. One of his *Autoscapes* of 1994 features the city of Ur, albeit as a landscape of void, but an ultimate site of origin nonetheless. Light, too, which backs up many of Wall's arrangements touches on the matter of origins, for light, like sound, acts in the present, which it intensifies to the

status of origin in its own right. And if the present can be considered as having the authority of origin, again there is no need to look further back into the inauthentic realm of mediations.

The problems of art in the late and post-modern period have been cultural. What scope was there for art in a period of cultural over-production? The most extreme responses have been capitulationists, accepting and merely registering the predominance of short-term cultural matter. If fact, as conventionally mediated, is sufficiently garish, why look further? Richard Prince's Marlboro countrymen belong to this domain, as do his wild bikers. Within photography 'proper' the capitulationist ethic informs the work of the Southern fragmentarians, most prominently that of William Eggleston. Faced with the enormity of culture, Eggleston's option has been to remark on what is passing – and thus he dramatises his own marginality as, for example, an itinerant punster.

What is lost hold of in any capitulationist system is the apprehension of the whole, although it may be intimated as an absence. Photography, which notoriously deals in fragments, contributes to this sense of loss, and the normal compensation has been to compose in series: *American Photographs*, for example, and *The Americans*. But the constructionists, by contrast, have proposed that culture should be bypassed in favour of a return to art. Any image which registers the cultural status quo, or even any part of it, raises the question of the whole of culture, which – like the question of origins – is beyond comprehension. Through construction, though, it is possible to forego the monstrous social question, and to propose a world apart: Sandy Skoglund is probably the most unabashed inventor of such milieux.

Recent art has been subjected to the control factor, also evolved to take care of contingency and the limitless. This usually took the form of inscription, which guided access to the picture and limited possible readings. Series, too, such as Douglas Huebler's cloud pieces projected the human urge to control as the autonomous element: what was on show was always less important than the procedure developed around the response to an original phenomenon. Ed Rusha's series on *Every Building on Sunset Strip* (1966) had less to do with vernacular architecture than with conceptual dominance. In British photography, especially the land art of Hamish Fulton and Richard Long, tracts of time and experience are summarised cathartically in terms usually of a mnemonic item and a title. In this way the sweat and disorder of the world at large can be set aside, and even overcome. As a mode, conceptual photography of this kind was late-modern to the extent that it proposed abstraction and management, and post-modern in that its procedures were impersonal. It was, and remains, a withdrawn art in which the artist figures mainly as operative, in which respect it has something in common with the fragmented photography of Eggleston, who makes a display of washing his hands of any responsibility for the whole. Clearly there are limits to either procedure, for once a

format has been established it can be replicated without end, to the point of denying authorship altogether.

What happened as a result of the impersonality established in the control process was that the product became detached from the producers, and artists' names took on a life of their own. The name, resolutely capitalised, became a thing in itself, and often enough part of a curatorial mantra. Constructed photography, with its renewed stress on invention and on accomplished pieces, re-established an idea of the author as essayist, an improviser responsible for the assemblage, and as once again vulnerable to charges of failure; a vulnerability which the process art of the last 20 years had all but ruled out.

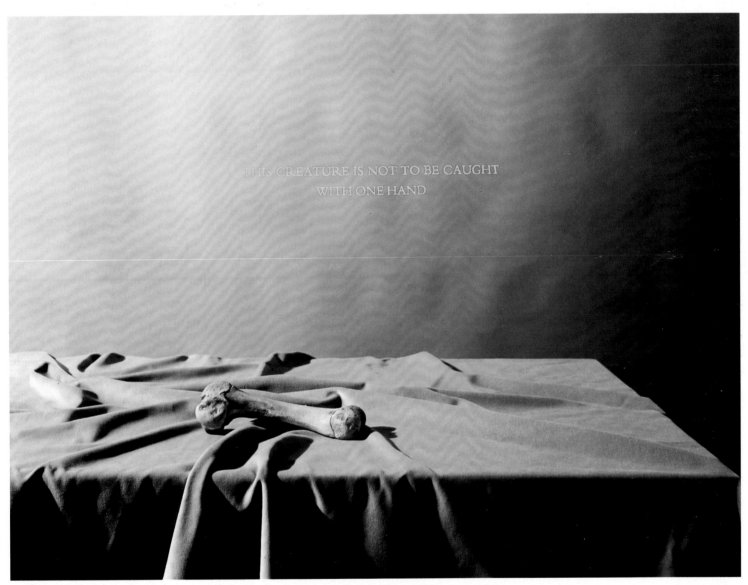

Olivier Richon, from The Hunt, *1995, c-type print*

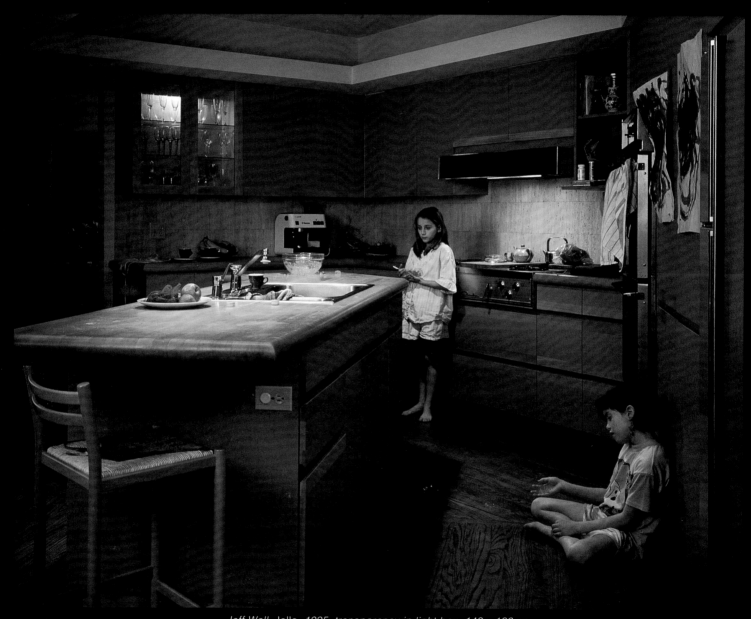

Jeff Wall, Jello, 1995, transparency in light box, 143 x 180cm

Since the late 70s, when he showed his first cibachromes, Jeff Wall has foregrounded the question of *genre*. Different types of picture – history painting, allegory, landscape, portrait – provide a repertoire not just of subjects but also of pictorial structures. His early reworking of typologies derived from French 19th-century Salon painting reflect upon the narrative structures of picture-making and showed his engagement with a Baudelairian notion of the 'painting of modern life' which corresponded with critical debates at that time which focused attention on the possibilities of a social-historical critique of the prevailing discourses of modernism. Wall's more recent work continues in this vein of deploying various pictorial structures, as well as mixing genres and types of picture, in what he has called a 'hybrid' process.

Wall first used digital technology in 1991 to produce *Stumbling Block*, and since then he has been able to build immensely complex pictures out of many individual photographic shots in a process which he has likened to film editing. Much of the most ambitious recent work has been made in this way, works such as *Restoration, Dead Troops*, and *A Sudden Gust of Wind (After Hokusai)*, although the recent series of still-lives were shot 'straight' in the cellar of Wall's studio in Vancouver. The still-lives introduce a new element by speculating upon the tradition of the 'art photograph' – a tradition which contemporary photography has moved away from – a past which is both remaindered and reintegrated in a contemporary hybrid form.

Almost all Wall's works are performed or staged, with the props and set forming a crucial, even compulsive arena of detail. The setting or location, the actors, the lighting and the props contribute to the overall scenario and are directed as a movie director might construct a scene. Wall's work is informed by an interest in cinematic effects and methods, but the arrested moment of the picture engages the viewer in figuring out a pictorial structure which requires a quite different relation to temporality. Even works which do not contain 'actors', like the still-lives, can be viewed as performative, with objects rather than characters acting out a scenario of some kind, though this time not a narrative one. In the figurative work the social and psychological placing of the characters is achieved through careful staging – often in urban scenes or near-wastelands on the edge of the city. Marginal areas of contemporary experience, a destitute figure on the street, for instance, or the eruption of violence in a street fight are charged with a feeling of unease,

both engaging a quality of sympathy with, as well as a detached distance from, the figurative content.

A historical trajectory of the work in a Baudelairian model of the painting of modern life is still evident in the work, but Wall's work offers a quite distinct symbolic scenario. The preoccupation with the minutiae of social experience goes hand in hand with the presence of an interior landscape, as a site of fantasy and uneasy psychic experience, at once compulsively interesting and potentially fearful. The treatment of interior spaces like a domestic living room exacerbates a now more claustrophobic but still acute, sense of uneasy peace. Rather than explicitly picturing traumatic events, there is an underlying threat of trauma or loss of identity. Pictures of groups of people talking beg the question of social and psychological bonds, believing in a collectivity whilst seeming also to doubt the possibilities of communication.

Wall's cibachrome transparencies are back-lit and mounted in aluminium display cases. Not only this sense of their objecthood but also the luminosity and often intense colour of the transparencies mark them out from a tradition of black and white photography. His use of figuration engages with traditions of painting as well as cinematic effects, a history of photography and even of sculpture. His self-reflexive mode of image-making presents pictures as if they have a memory, and as if the past of representation is always (and indeed only) present in the 'now'. He has said that he is interested in a figuration which comes out of modernism, rather than a figuration which imagines itself independent of that history of modernism.

This work may be seen in terms of a critique of modernism, of its preoccupations with autonomy and abstraction, but one in which figuration is worked through that history, emerging from it rather than avoiding it. In recuperating possibilities for figuration for the literary possibilities of narrative, and in adopting photography as its medium and its means, Wall goes against the grain of the modernist aesthetic; yet in reflecting upon the limits and boundaries of the medium of the art work, in a way he engages in a strategy which can in certain respects be linked back to a modernist one. This 'double action' in his work reveals a complex and radical strategy which undermines a confident belief that the past has been superseded and posits instead a much extended sense of what the present, including art-making in the present, can be made of.

Jeff Wall, Man in Street, *199*

ransparency in light box, 52.7 x 132cm

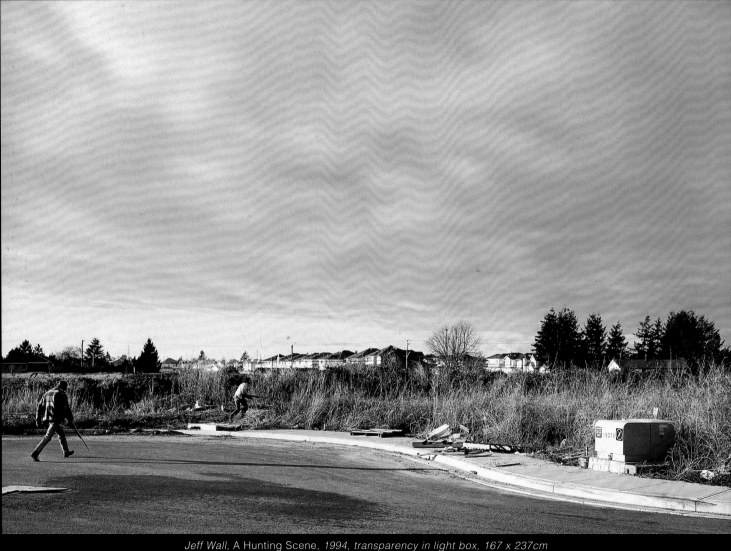

Jeff Wall, A Hunting Scene, *1994, transparency in light box, 167 x 237cm*

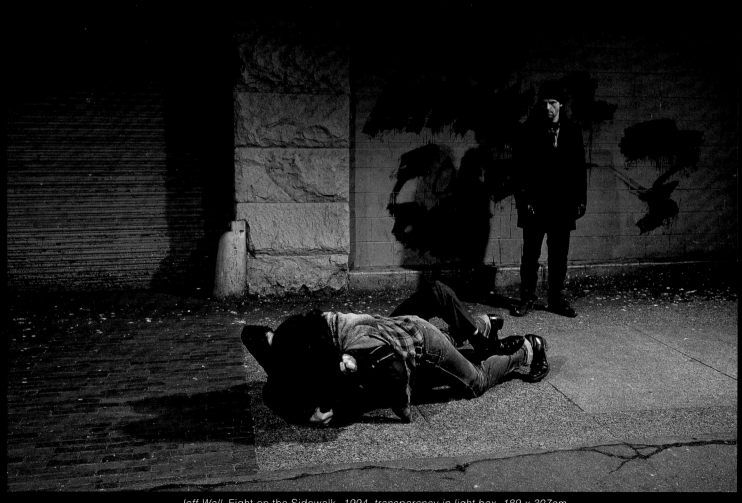

Jeff Wall, Fight on the Sidewalk, *1994, transparency in light box, 189 x 307cm*

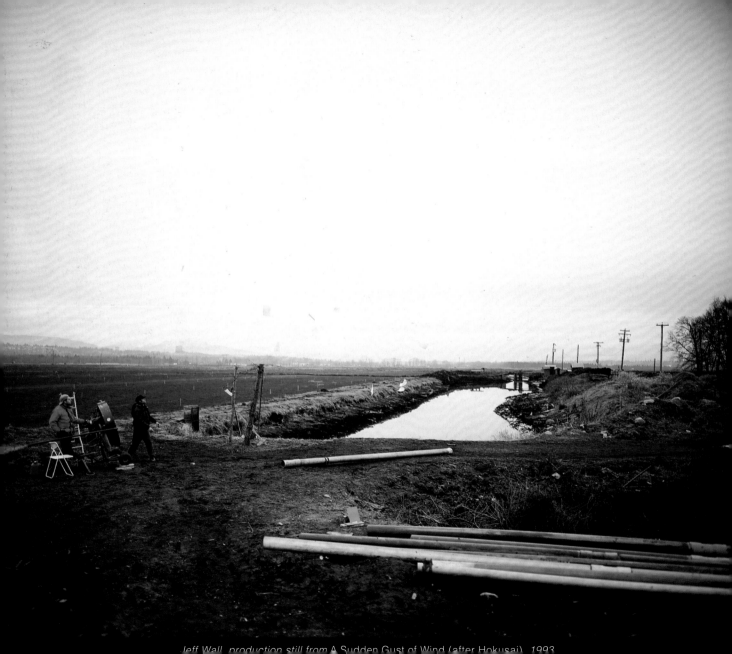

Jeff Wall, production still from A Sudden Gust of Wind (after Hokusai), 1993

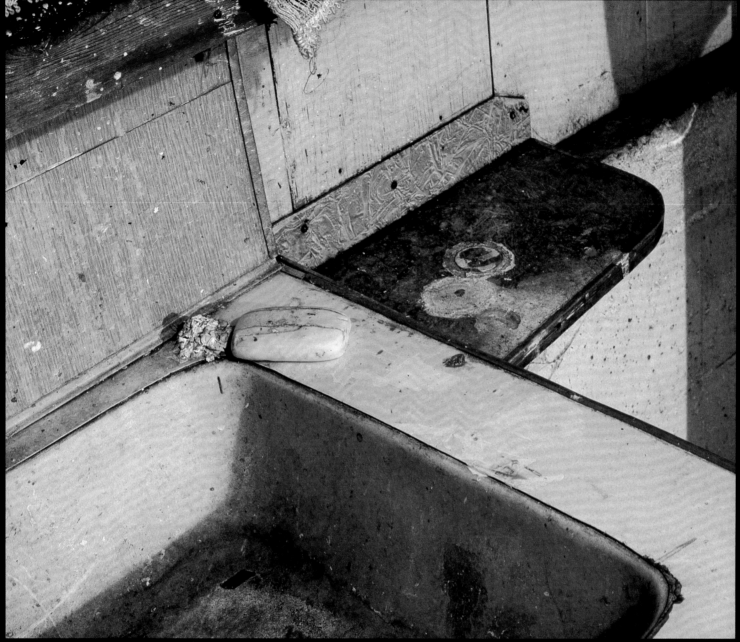

Jeff Wall, Diagonal Composition, *1993, transparency in light box, 40 x 46cm*

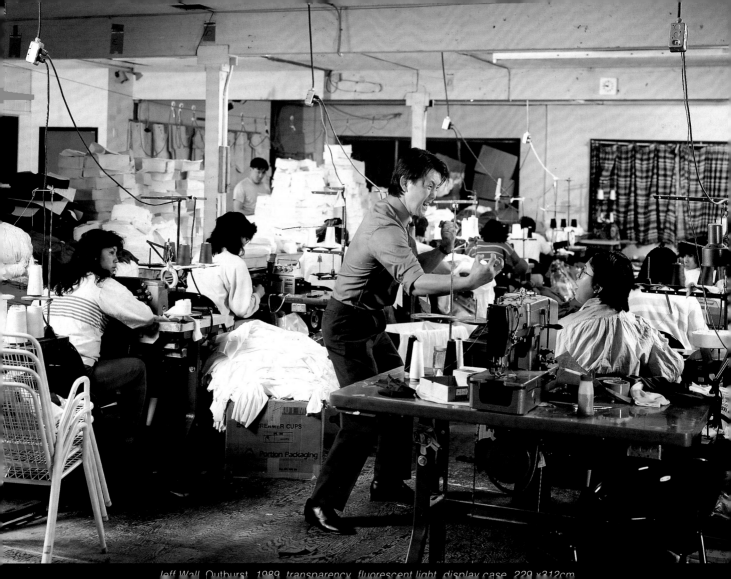

Jeff Wall, Outburst, 1989, transparency, fluorescent light, display case, 229 x312cm

IV

THE FRUSTRATIONS OF TRANSGRESSION

Andres Serrano, The Morgue (Rat Poison Suicide), *1992,*
cibachrome, silicone, plexiglas, wood frame, 125.7 x 152.4cm

Andres Serrano, FROM ABOVE: The Morgue (Death By Drowning II), *1992;* The Morgue (Hacked to Death), *1992; both of cibachrome, silicone, plexiglas, wood frame, 125.7 x 152.4cm*

88

FROM THE CARNAL TO THE VIRTUAL BODY

David Alan Mellor

To stand in front of Serrano's photographs is to come before some grave presence, at once monumental, lavish and dangerous, with no threshold but the grave. He is an artist of forensic detail, who scrutinises the surfaces of life in death, and the inert. His series of studies of revolvers summon up one recent definition of the ugly – 'a punitive force which is sweeping toward me'[1] which forces the viewing subject to look away. This over-running of ourselves as spectators comes about – in part – by his use of certain gazes, threatening objects and a renewed Catholic metaphysic held (sometimes literally), in suspension. Looking down the wrong end of the defocused barrel of his *Colt D.A.45* the spectator glimpses red points of light – warning *puncti* – deep in the chambers of the gun's magazine. It is this dimension of 'provocative intent'[2] which Serrano has been impressed by in the Benetton campaigns of Oliviero Toscani: an intent which tantalises the aggrandised gaze and might still hold it, in order, Serrano has written, to 'question the questionable'.[3] The eye of death unsettles, and nowhere more so than in *The Morgue (Hacked to Death II)*. This eye which was horizontal in life is now vertical and null, like the parted lips in *The Morgue (Death by Drowning)*, a blank alley into the chambers of the dead body. This dead eye might be considered an analogue of Janet Leigh's scarifying but recessive eye at the spiralling close of the shower sequence in *Psycho*: a masochistic, introjected gaze, which we might identify with, aggressing and aggressed, standing over in the role of authority or that of subjected being.

Serrano presents us with varieties of patriarchal spiritual authority. He appears to locate them through the surrogate eye of God, charged with spiritual administration in *The Church (Father Frank, Rome)* behind glasses; elided in *profil perdu*, in *The Church (Soeur Yvette II, Paris)*; off-centred and void in the *Klansman* series. The mechanics of vestimentary concealment are at work to hide the flesh and the eyes: occluded heads occur with his metropolitan nomads, the modest nun, the dead of the morgue and behind the badly seamed eyelets of the Klan. These hoods and hats disclose a particular iconography of presiding figures made sanctified and possibly even invisible, close to the celestial realm and therefore to death and the shroud. The seat of reason is occluded, the body no longer ensouled and, in the *Morgue* series, the soul has departed, via those affecting mouths, aided by angels whom Serrano has not yet pictured. The soul's absence is flagged by Serrano's system of facial curtainings and spectacular framings, such as the scarlet cloth over the upper head in *The Morgue (Infectious Pneumonia)*. The Christian and Neo-Platonic connotations of this colour – charity and love, as well as heat, light and maleness – can be contrasted with the cold, heavy, earthen appearance of that 'feminised' matter which constitutes the dead in the Morgue series, especially in *(Death by Drowning II)*. This establishes a system of meanings which acquire further density in terms of Julia Kristeva's analyses of the origins of abjection. Patriarchal spiritual authority is present at a perturbed, bloody spectacle, with the church personified as averting itself in Serrano's tableau *Heaven and Hell* from a subjected and polluted woman's body.

Serrano has re-circulated Catholic Baroque iconography while simultaneously subverting it, resuming it as part of that ascendant cultural moment which Celeste Olalquiaga has called 'The Latinisation of the United States', whereby '. . .Catholic religious imagery provides access to a variety of intense emotions that seem otherwise to be unattainable'.[4] This supplementation can be seen in culturally contentious films such as Martin Scorsese's *The Last Temptation of Christ* or the metropolitan sublime of Abel Ferrara's *Bad Lieutenant*, with its apparition of the suffering Christ to a corrupt, libertine New York policeman in a defiled church. The reflux of Catholic cultural formats – Harvey Keitel as *penitente*, the devotional vernacular *altares* produced by Larry Clark in his gallery and book collages – have worked primarily around sacrificial violence to the incarnate body. Ten years ago Serrano photographed *Pieta*, where the conventional iconography of the sanctified body of Christ, lying in the lap of a mourning woman, was substituted for a large mullet, a displaced, phallic, embodiment and re-textualising of the Greek coding of Christ as *ICTHYS*, fish. Serrano has intuited and represented that key element in sacrificial violence – here Christ's Passion – which was identified by Rene Girard where, 'the surrogate victim meets his death in the guise of the monstrous double'.[5]

This great fish as a monstrous double of Christ's body, held in the arms of a cloaked market seller, also suggests the kinds of verism which were present in Baroque Spanish Realism, the low *bodegones*, and the pietistic paintings of Ribera and Zurburan which he may have encountered during his visits to the Metropolitan Museum in New York. Serrano's version of corporeality – in his *Morgue* series, for example, or the elderly life-class model in the *Budapest* series – revisits the bases of the Baroque enquiry into the human body supported by scientific as well as religious accounts of death. The Spanish cultural historian JA Maravell has written of that period's 'macabre iconography' in ways which we might associate with Serrano, as being condi-

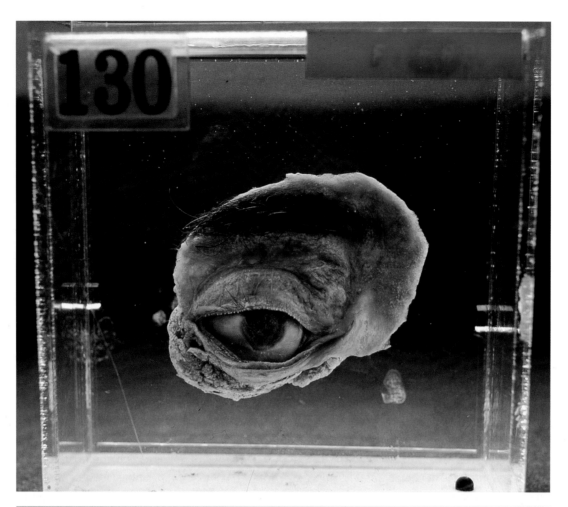

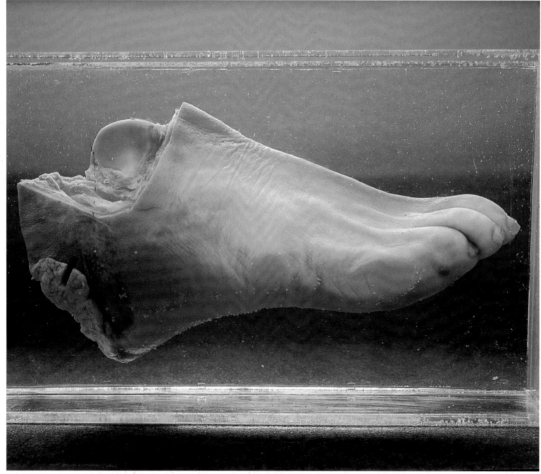

Zarina Bhimji, FROM ABOVE: Eye, *1995;* Foot, *1995; both lightbox installations, from the* Listen to the Room *series*

tioned by:

> ... anatomic knowledge and the interest in scrutinising the composition of the human body by examining ... the alterations undergone by the cadaver. On the other hand those funeral representations were inspired by the zeal in making a studied penetration of the structure of existence, to whose essence inexorably belonged the final step of death.[6]

It is possibly an unsure and uncertain belief in the Resurrection, that 'happy result of supreme violence'[7] which questioningly underpins Serrano's *Morgue* series, an address to Christ's Passion which Serrano has already placed at the centre of his visual reflections on sacrificial violence. The *Morgue* photographs search for taints of corruption and decay with a solemn gravity. In this they are different from the carnival buffoonery and black humour activated in Damien Hirst's promotional morgue photographs. Serrano seems caught up in a quandary with the mechanics of certitude, verification and the witnessing of the condition of saint's bodies, both alive and dead. Zurburan, for instance, painted the long dead but miraculously incorrupt St Francis; stiff, stark and terrible.

Along with forensic medicine and a contemplation of Catholic positionings of death as sources, Serrano has also recovered, for his own critical purposes, that Baroque insistence on physiognomy, on the countenance as seat of human identity. Perhaps this last aspect is best seen in his *Nomad* works, portraying the heroines and heroes of the metropolitan margins as monumental and thoughtful figures, who beneath their saintly hooded headgear are possessors of a dignified inwardness of countenance, thereby upsetting those conventional alignments of social status and prestige in the discourses of portraiture.

A certain sombre light steals over the skewed forms that twist in the Klansmen's hoods, the hammer of the Magnum .44 revolver, and the body-towers of the Nomads. But effulgence as well as blackness, those twin poles of undifferentiation and of the dissolution of the flesh, are at play. The black of Father Frank's cassock is met with the glow around *Female Bust,* like the nimbus of blond and golden light surrounding the *Purisima*, the *Immaculada*, who, in her utter incorruption as sign of her freedom from sin, were eternally in God's thoughts. Such an effulgence around submerged signs of Christianity and pagan iconography serve to accommodate Plotinus' philosophy of spiritual light – noology – a diffused, translucent but internal light emanating from the One, a pure effluence transmitted to other souls. But the course of Western Catholicism veered from this goal of the human soul achieving 'fusion in divine light. Instead the aim is man's resurrection inside a spotless and glorious body'.[8]

With his immersed bodies of Christ and Venus, Serrano has produced a commutation between these poles. Part of Serrano's transgressiveness could be the switching of 'vile substances transformed into [the] precious'[9] in this linking of the immaculate but pagan, (the bust of Venus) with a Christian visual rhetoric, (the nimbus), all steeped in urine. At the locus of scandals; *Piss Christ*. The tracers and clusters of glistening air bubbles which adhere to the inner surface of the glass tank also seem to support the inanimate body, aerating it with an oxygen that fails to revive. Systems of fluid and bodily exchange circulate about in the hellish dusk. Serrano's economy of fluids is male and in the *Untitled, (Ejaculate in Trajectory)* group of photographs, a certain essence scarfs past the camera like psychic matter passing from a spiritualist medium's mouth. The capitalist order of the white West, according to Alphonso Lingis, 'does not transact with body portions or body parts',[10] but with productive wealth. The bloody scenes of shamanic ceremony and sacrifice, constructed at the outset of Serrano's career, were an important reminder of other orders of culture offsetting the West. 'In our economy, body fluids flow quite outside of, and beneath, our political economy ... unmentionable in our socially significant discourse'[11]. Yet in Serrano's symbolics, 'the vital fluids transubstantiate as they pass from one conduit to another',[12] arrested at the aporia of defiling that great signifier of the unarguably immaculate and untouched by sin, Christ.

Such an aporia can slide towards a corrosive scepticism towards Catholicism and the modernist blasphemies of Max Ernst and Luis Bunuel. It is present in Baudelaire's citation of Voltaire as hater of religious mysteries: 'In *Les Oreilles du Comte de Chesterfield*, Voltaire jests about our immortal soul, which has dwelt for nine months amidst excrement and urine'.[13] It is this notion of a parodic gestation and a perverse natural term for the soul that arise in relation to Serrano's immersion pieces and their amniotic carrying of Christ's body. Stillness and the passage of time act as vectors during this potentially desacralised duration, miraculously maintaining the Crucifixion in a mire of human waste made luminous. Such vapours and fluids, according to Adrian Stokes' reading of the translucent landscapes of the painter JMW Turner, are at once foul and transcendent, born of the male bodies' deepest fantasies of phallic power, waste and authority:

> ... the conception ... of the infant who believes in the omnipotent and scalding propensity that belongs to his stream of yellow urine as it envelops the object so closely attached to himself, an object split off in his mind from the good breast with which he is one.[14]

Turner's secular uses of the Sublime – of vast, liquefying and vaporising natural forces, and the annihilation of human measure – are also recalled by Serrano's aggrandised, scaleless interior landscapes of body fluids. *Bloodstream* appears like a Turnerian meteorological event, a big exterior phenomenon, a tornado of blood; yet framed inside a body whose limits we do not see and which must far exceed the frame of the photograph. It resembles a sublime special effect like de Mille's realisation of the crossing of the Red Sea in *The Ten Commandments*, appropriated by Spielberg in the 80s, an unsafe passage of red through an abominable sea. The monstrous, in recent transgressive photography, is located either in the asepsis of cyberspace, as with Inez van Lamsweerde's digital chimeras, or else in some originary

– often amniotic – fluid world. Sometimes these two scenarios are combined. Oliviero Toscani's newly born baby, promoting Benetton, comes timely into the aseptic, white world as an organism attached and covered by fertile supports and abject fluids. It is still to be severed from that maternal body with the cutting of the umbilical cord, while growth through further cuts and losses and developments lie ahead. What occurs in the formaldehyde frames of Zarina Bhimji's photographs and Damien Hirst's sculptures is, by contrast, an ultimate stabilising of growth and loss. Serrano's offerings of body materials and sanctified statues of the human body invoke that internal *claustrum* where paternal and maternal figures persist – as aeons pass.

The phenomenological uncovering of tears in the fabric of the body is a widely distributed characteristic of current transgressive photography. Larry Clark's *1992* narrates 'coarse self-cutting'[15] as a disturbed body management strategy of adolescent males and provides a metaphoric opening to his recent *The Perfect Childhood*. In this book, after initial, heavily mediatised, abject and low-resolution video images of youths' portraits, their clear and scarred legs provide another introduction which is inclusive of the intimate body. Nobuyushi Araki has scratched his prints in order to hide or erase genitalia as a way of marking the mark of socially convened pornography. Serrano's *The Morgue (Knifed to Death I & II)* also marks the points where blood has extruded through intrusions into the body, with wrist and hand cuts that irresistibly reiterate the stigmata of Christ's wounds. In his recent essay, Robert Hobbs has cited their resemblance to the envivifying contact of God the Father to Adam in the Sistine Chapel's *Creation of Adam*, where Adam is an ante-type, or prefiguration of Christ. These subcutaneous touches, in Serrano's *Morgue* series, are a mix of records of third party aggression as well as self-wrought injuries, injuries that track a fantasy positioning of victim and self as aggressor or aggressed, that also work to undo the fevers and fixities of gender roles.

It is relatively minor key Oedipal self-mutilations which Clark documented in 1992; much transgressive photography goes further along the flesh's road to the *corps morcelé*, the body in pieces, as in Cindy Sherman's dismembered prosthesis tableaux. As Linda Nochlin has observed: 'The Post Modern body, from the vantage point of these artists and many others, is conceived of uniquely as the "body in pieces" '.[16] Such psychic wounds proliferate in the massive traumas inflicted on the male body in the animatronic cinema of special effects. From the self-regenerative holes blasted in the head and upper body of the T-1000 in *Terminator 2*, which then reforms, with no trace of physical injury, to the slits, the intrusions below the skin, perpetrated on Steven Cronenberg's heroes and heroines: the spectacular display of the wound is as central as it is to the paintings of Francis Bacon. This 'celebration of the wounding process'[17] differs from that scene of medical enquiry around the stressed body and cadaver which exercises artists as far apart as Hirst, Matthew Barney and Zarina Bhimji. All of these artists

annex decor and paraphernalia from the medical scene that serve to supplement, suspend, irrigate and preserve the body. Hirst's colostomy bags for the absent subject, Barney's prosthetic plastic frames for his Mortensen-esque satyrs speak, however, of a distance which is annihilated in Bhimji's exploration of body parts through immediate fragments.

This scene – that is, the one composed by Serrano and Bhimji – constitutes a specifically uncanny inquiry into the opening that surgery makes, or the moment of the autopsy, or the residues, the carnal precipitates of death. Serrano's photograph of a fire victim's reddened, plasticised lung membranes or the softened pink, folded, edges to the abstracted feet, eyes and penis in Bhimji's pictures of organs in formaldehyde jars, are photographs in an uncertain register. They rehearse a part of the Freudian *unheimliche*: 'this feeling comes from the uncertainty whether a thing is alive or dead'.[18] Bhimji's aged, unblinking eye from the Public Art Commission at a London hospital's Pathology Laboratory, appears tired and rheumy, but sentient, alive despite its radical detachment from a unified body. One implication which Bhimji suggests, is a fascinated (held in that fixed gaze of the detached eye) admission, by the enchanted, perplexed and horrified spectator that, in her words: 'The coherence of the body is shattered'.[19] The principle of ocular verification of a deathly state – the literal meaning of an *autopsy*, to see for oneself – is mirrored back by an unseeing eye at the site of the still physical 'archiving of body parts'.[20] The flesh dissolves from unity to an independence of organs, surfaces and isolated body cavity vignettes.

In Steven Cronenburg's important films from the early 80s such as *Rabid* and *Videodrome*, the body – demoralised – opens itself to the new digital technologies and goes its own way; in Cronenberg's own words it is severed from the residues of that theological matrix which Serrano epically contends with: 'I don't think that the flesh is necessarily treacherous, evil, bad. It is cantankerous, and it is independent. The idea of independence is the key. . . relative to the mind'.[21] Bhimji's pathology lab organs in formaldehyde restore a pathos to the body in pieces which Hirst evacuated; they are independent objects, possessed of their own suspended gravity, set aside, plush at their linen edges, like the fabrics Bhimji adorned her earlier photographs with, festooned with memories of incorporation into that larger entity. But these are things ripped from the interior folds of the body, like Mapplethorpe's double gesture with the bull whip handle at his anus; once in a fantasy a part, drawn in, but also expelled, split off.

To excise parts from the body, or to open it, as a 'male coarse self-cutter',[22] and to amputate, suggests a strategy of self-manufactured feminisation, as if in a fantasised auto-castration. Beyond the youth masochism of Larry Clark, Nan Goldin's *The Other Side* and Bettina Rheim's *Kim* are books which have recently chronicled ultimate extensions in this direction and further, beyond transsexual identities. Goldin and Rheims trace

an image of a contemporary will to androgynity: Goldin's friends are celebrated by her as 'a third gender that made more sense than either of the other two'.[23] Diaristic personal testimony provides a generic framework for these books: in Goldin's case with photographed portraits where the lower framing edge of the pictures repeatedly cuts across their bodies at their torso to metaphorically repeat the erasure of their primary male sexual signifier, thereby obstructing our scopic drive to verify a fixed sex. The troubled pursuit of this hidden perfection found in a disordered liminal body, results in displeasure for certain viewers. Kim's written testimony of her surgically altered body indicates as much: '. . . some men – well most men, really – are a bit uncomfortable with us because we've decided on this voluntary castration'.[24] The representation of a changed identity for the body is, arguably, also the pursuit – with different topics and a different gender – of Inez van Lamsweerde's depictions. Her acknowledgement, in one of their titles – *Thank You, Thighmaster* – of an altered flesh, a mastered flesh, transformed on a previously insufficient body, is possibly the declaration of a 'mutant *chic* . . . (where) wilful deformity could be seen as beautiful'.[25] One instrument of such a will to deform is the very same means which Van Lamsweerde uses to produce her images – that is, digital manipulation. Donna Haraway's *Manifesto for Cyborgs: Science Technology and Socialist Feminism in the 1980's*, written a decade ago, indicated the possibility for a radical transformation of subjected female flesh, a utopian diversion from corporeality into 'a world populated by cyborgs. . .a world without gender or origins and without end',[26] that would produce virtual beings whose customary human identities would be dissolved.

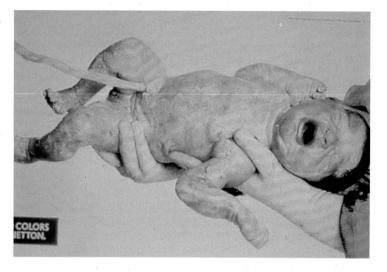

Van Lamsweerde satirically presents virtual women and female children at the moment when they are lifted beyond the abject and acquire non-secreting, seamless, sleek, static and closed bodies in a parody of screened consumer perfection. With genitals absent, they are as baffling as the barred and beautiful bodies of Goldin's transsexuals because they are as equally unresolvable and are futuristically unverifiable, despite their paradoxical 'high-rez' appearances. They are immaterial enigmas of technotronic fabrication: unlike the palpable flesh of Bhimji's nostalgias, these body parts have been digitally archived, their author possessing 'the power to download the body into data',[27] material girls who carry no metaphysic on the outside of an artificial skin, smoothed with the gaze and resemblance of an alien abductor.

A mistrust of the skin as an adequate, permeable container is betrayed in Van Lamsweerde's imaging of an impermeable, synthetic skin, perfect and repulsive, the manifestation of an immovable marking boundary with the world in an epoch of messed up-boundaries. If Orlan stands as one overcoming of the limitation of flesh and skin, with bruises, scars and imprints of Venus and all, then Van Lamsweerde suggests another variety of grafted, recombinant skin: but without the bruising or scarring

FROM ABOVE: Damien Hirst, With Dead Head, *1991, black and white photograph on aluminium, 57 x 76 cm; Oliviero Toscani,* Benetton Newborn Baby, *advertising poster*

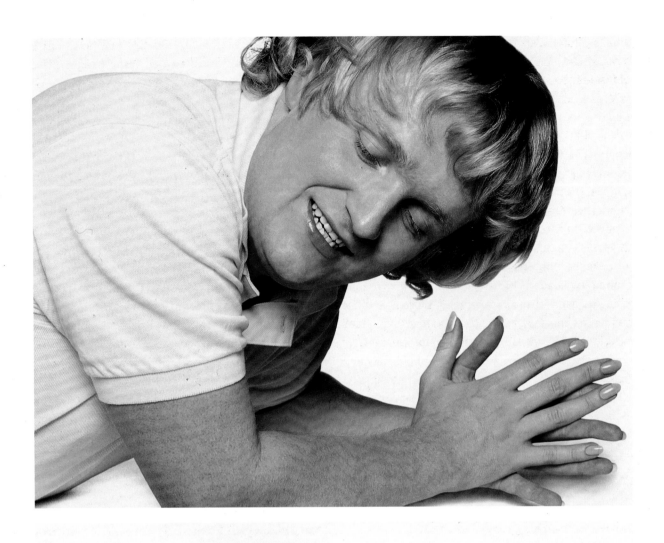

Inez van Lamsweerde, FROM ABOVE: The Forest: Marcel, *1995, photoprint in perspex, 180 x 135cm;* Final Fantasy Topaze, *1993, duraflex/ perspex, 100 x 150cm*

that attend Orlan's efforts. Van Lamsweerde has written of the sealed nature of the skin surfaces she has figured, as possessing a sense of insides 'packaged in an artificial shell . . . people shut in themselves'.[28] Of their amorphous interiors and body cavities we cannot know or tell, but we have an intuition of the nullity attached to that 'packaging', and, by extension, to the promotional world. This is Van Lamsweerde's ambiguous area of profession, particularly in that complicit sector which has made claim to the status of promotional transgression, as in the case of the so-called 'neo-advertisement' developed by Oliviero Toscani, (of which the newly born baby was one). Commentators from within the advertising industries have identified a financial imperative to colonise the imagery of transgressive body customisation and modification – 'to steal in on these images to repossess the imagination of today's youth'.[29] While this tactic proposes a way of circumventing the sheer, seamless surfaces of a certain perfection in visual advertising for an aura of authenticity, Van Lamsweerde stays with the will to virtuality and redoubles it, making it unstable, comic and strange, foregrounding what Arthur Kroker has called 'abuse value'.[30] Peering in the mirror of Van Lamsweerde's cyber-skinned women: 'The flesh will then be able to contemplate itself as magazine flesh – smooth, glossy and clear'.[31]

In a fashion feature for *The Face* in 1994, Van Lamsweerde constructed a sequence of mediatised images of contemporary maladies and scenarios of ecological fears called 'Global Warming TV', like an illustration of Arthur Kroker's claim, in *Data Trash*, of sophisticated Western viewers' narcissistic enjoyment of media visions of global catastrophe. The motif of the fashionable body as a hyper-managed, fetishised and a virtual organism, jubilating over the fragility of the life-world, is centred by Van Lamsweerde upon a woman doctor, macabrely ecstatic over a (male) child patient digitally patched into the scene. This perverse tableaux, with its electronically contrived Harpy, suggests a Sadeian laughter and a violation of all former trusts and intimacies. Most formidable of all Van Lamsweerde's photographs have been the *Final Fantasy* series, where the liminal openings of the children's eyes and lips have been replaced by adult version of those body parts. Bits of the carers are implanted, sutured digitally, as *puncti*, as details which reverse the *studium* of the infant's body as a socially convened site of innocence: here some over-age knowledge has been incorporated in the places of sight and nourishment – and by analogy, excretion – those edge zones where unconscious and enigmatic prompts are indeed given by the mother.

Notes

1 M Cousins, 'The Ugly', *AA Files*, No 28, pp61-64, p64.

2 A Serrano, *Benetton par Toscani* (Lausanne) 1995, p167.

3 Ibid.

4 C Olalquiaga, *Megalopolis* (Minneapolis) 1992, p53.

5 R Girard, *Violence and the Sacred*, 1992, p251.

6 J A Maravell, *Culture of the Baroque,* 1986, p65. Maravell is citing A Chatel, 'Le Baroque et la Morte' in *Retorica e barocco*, 1969, pp33ff.

7 R Girard, op cit, p247.

8 E Alliez and M Feher, 'Reflections of a Soul', *Zone,* 'Fragments for a History of the Human Body' Part II, 1989, pp46-85, p58.

9 M Camille, *Image on the Edge*, 1992, p114.

10 A Lingis, *Foreign Bodies*, 1994, p136.

11 Ibid, p140.

12 Ibid.

13 C Baudelaire, *Intimate Journals*, 1989, p37.

14 R Wollheim, (ed), 'Turner', Adrian Stokes, *The Image in Form*, 1972, pp211-35, p223.

15 Cf L J Kaplan, *Female Perversions: The Temptations of Emma Bovary*, 1991, p369.

16 L Nochlin, *The Body in Pieces*, 1995, p54-55.

17 C Bernheimer, *Flaubert and Kafka*, 1982, p96.

18 Mike Kelley, cited in relation to his curating of the Arnheim 'Uncanny' exhibition; E Troncy 'Les Limites de l'esthetique du divers', *Documents* No 4, October 1993, pp17-19, p19.

19 Z Bhimji, *Art in Hospitals Proposal*, Public Art Development Trust, 1995, unpaginated.

20 A Kroker and M Weinstein, *Data Trash*, 1994, p104.

21 C Ridley, (ed), *Cronenberg on Cronenberg*, 1992, excerpted in 'Long Live the New Flesh!', *Mondo 2000*, No8, 1992, pp86-90, p88.

22 Cf L J Kaplan, op cit.

23 N Goldin, *The Other Side*, 1993, p5.

24 B Rheims, *Kim* (Munich) 1994, p23.

25 C Jones, 'The Cutting Edge', *The Face*, September, 1994, p81.

26 D Haraway, *Socialist Review*, No 80, 1985, quoted in C Tamblin, 'The River of Swill . . .', *Afterimage*, October 1990, pp10-13.

27 A Kroker, op cit, p134.

28 P Terrehorst 'Een Alarming Model', *Perspektief*, June 1994, pp62-67, p64.

29 L Faber, 'Under Your Skin', *Creative Review*, April 1994, pp40-43, p43.

30 A Kroker and M Weinstein, op cit, pp113-14.

31 Ibid.

Inez van Lamsweerde, Enter, *1995, for theatregroup Mug met de Gouden Tan, Amsterdam, paintbox manipulation by Kim Mannes-Abbot for Souverein M2 Projects*